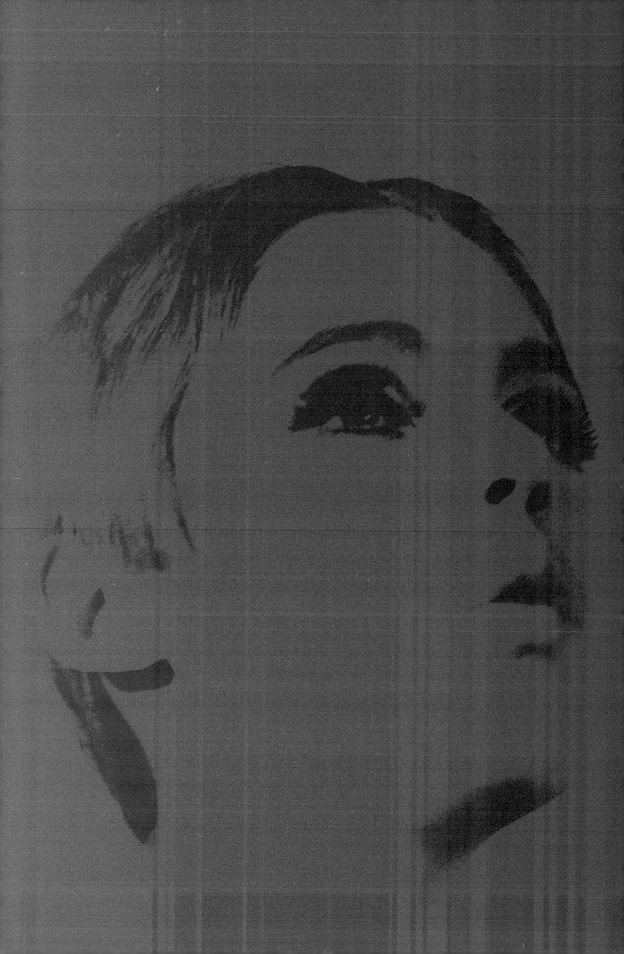

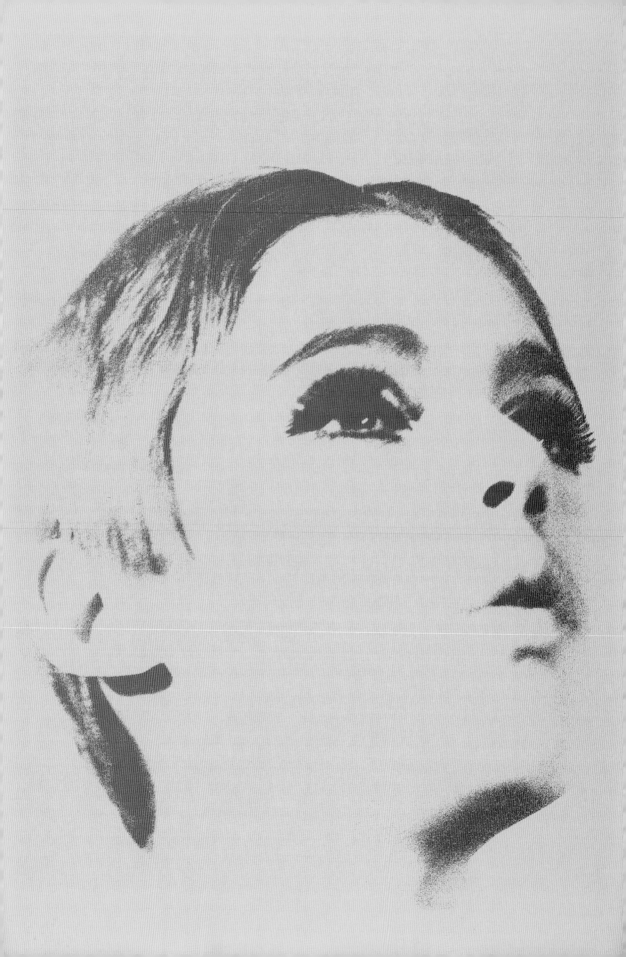

EDIEFACTORYGIRL

EDITOR: Jacob Hoye **ART DIRECTION / DESIGN:** Gabriel Kuo | BRM

FIRST PUBLISHED IN THE UNITED STATES OF AMERICA IN 2006 BY VH1 PRESS

A Division of MTV Networks
1515 Broadway
New York, NY 10036

Photographs © 2006 Nat Finkelstein
Text © 2006 David Dalton
VH1 Press and all related titles, logos, and characters are trademarks of Viacom International Inc.

Distributed by powerHouse Books
37 Main Street, Brooklyn, NY 11201
PH 212 604 9074 FX 212 366 5247
powerHouseBooks.com

FIRST EDITION
2006 / 10 9 8 7 6 5 4 3 2 1
Printed and Bound in China
ISBN: 1-57687-346-3
Library of Congress Control Number: 2006929112

ACKNOWLEDGMENTS

DAVID DALTON :
I am indebted to you, shining ones of the lost kingdom of Warholia, for your generous commentaries: the radiant Bibbe Hansen, the beatific Billy Name, the hipster-noirish Robert Heide, the soigné Ultra Violet, the quasi-mythological Marianne Faithfull, the wry insider Danny Fields, and my dear sister, Sarah Legon. Also to fellow writers Gerard Malanga, Chuck Wein, and Ron Tavel, all of whom I had previously interviewed (and who can easily supply their own epithets). Not to mention the young followers of the Cult of the Leopard-skin Pillbox Hat: Jane Andersen, Anoushka Beckwith, and Sana Amini. My gratitude to Jim Fitzgerald for getting it all together; and to Jacob Hoye for his sensitive macro/micro editing. And lastly but not leastly, to my wife, Coco Pekelis Dalton, the other half of my brain (and heart).

NAT FINKELSTEIN :
Elizabeth Murray Finkelstein, Jane Alexander, friend & helper, the magnificent Miss Sara Rosen, Nathalie Belayche, PICTO Laboratorys (Paris), Jim Fitzgerald.

To our wives, Elizabeth and Coco.

ALL PHOTOGRAPHY BY NAT FINKELSTEIN EXCEPT

COLLECTION OF DANNY FIELDS : pages vii, viii
BILLY NAME / OVOWORKS, INC. : pages 21, 38-39, 40, 61, 88, 90, 98, 129, 150
DAVID MCCABE : pages 52, 65

PRODUCTION CREDITS

PRODUCTION SUPERVISOR : Patti Rogoff
PRE-PRESS PRODUCTION : Anthony Bonamassa
PRINT PRODUCTION : Nancy Morelli
PROJECT MANAGERS : Lollion Chong & Karla DeMichele

EDIEFACTORYGIRL

NAT FINKELSTEIN + DAVID DALTON

SPRING 1965

I'm at a party at the Dakota, a gothic mountain of a building on Central Park West.
A sprinkling of literati; Norman Mailer (pontificating), the art collectors Bob and Ethel
Scull (loud, obnoxious), real-estate tycoons, hairdressers, Leonard Bernstein, and all the
glittering rabble of mid-'60s New York. Everybody's growing their hair just a bit longer,
trying to get hip, trying to get high. Andy Warhol's here in his silver cocoon of aphasia
and passivity. I know Andy—my sister and I were his first art assistants. He's here with his
current helper, Gerard Malanga, as well as Baby Jane Holzer and other members of his
entourage. The usual drone of cocktail party chatter, "Eight Days a Week" playing softly
in the background. Suddenly, a strange girl in black tights, striped t-shirt and giant earrings
enters the room. With her odd birdlike gait, she twirls into the very center of the room
and remains there, simply . . . twirling. A few giggles. Someone wonders what she's on,
poor thing. But as they're talking, right under their very noses, the room begins to spin.
Edie's world is a kind of merry-go-round—you either get on one of those ornate plaster
horses or you're left standing there, watching them go round and round.

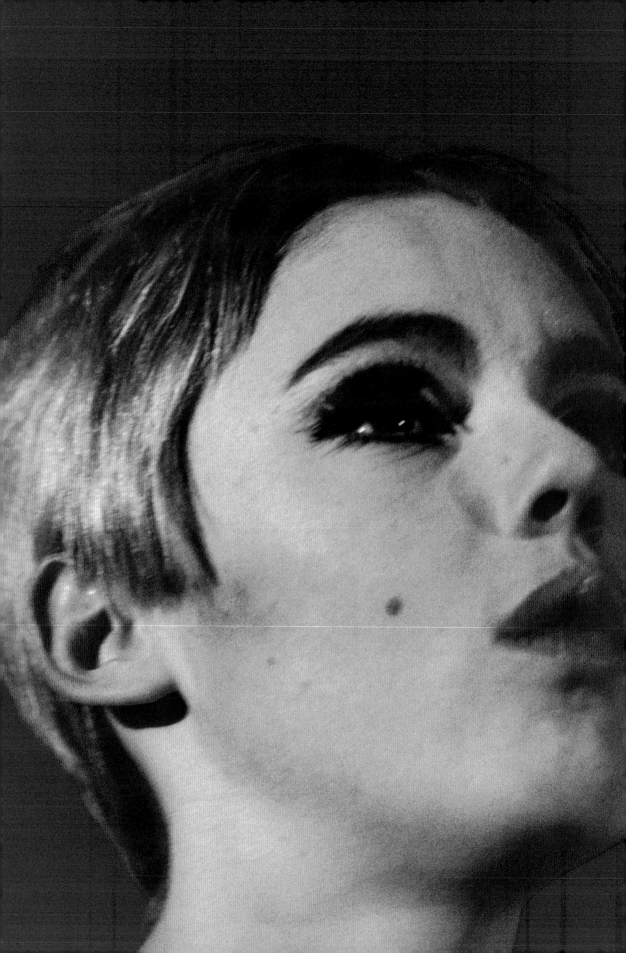

"Oh, she's so fab-ul-ous," Andy sighs.

"Who is she?" I ask.

"Oh, that's Edie Sedgwick. She's one of the Cambridge kids. We're going to make a movie with her."

At first I think it's just Andy being droll. After all, there are no women in Andy's movies. Buildings, horses, haircuts, a man sleeping for six hours, and assorted gay hi-jinks, but definitely no women.

The Long-Time Curse Hurts

Edie Sedgwick, the seventh of eight children, was born into a haunted aristocratic family whose roots went back to the Pilgrims—god-mad zealots who were driven further into dementia by their pointless errand into a trackless, savage-infested wilderness. A gothic family written by Hawthorne or Poe. Vastness, isolation, and sin sent grown men mad in broad daylight and made the women bitter and batty. You have only to read a few lines of one of Jonathan Edwards poisonous sermons such as "Sinners in the Hands of an Angry God" in which parishioners are likened to "some noisome insect . . . thrown into the midst of a fierce fire burned into a bright coal" to recoil with revulsion and horror at the displaced medieval masochism and Puritan paranoia. The Salem witch hysteria infected the Sedgwicks with gothic horrors that would be passed down even unto the sixth generation thereof.

This is the family that Edie did everything to reject, expunge, and replace with her own mutant genes. "The moss-grown rotten Past is to be torn down," Hawthorne wrote in *The Blithedale Romance*, "and the lifeless institution to be thrust away, and their dead corpses buried and everything begin anew." Edie's great-great-great-grandfather Judge Theodore Sedgwick is the Big Bang of the Sedgwick clan—and right at the very start we find madness in the family. His wife Pamela, driven round the bend from spending long frigid winters alone in a gloomy demon-polluted house, went quite mad. Her tombstone reads:

"SHE LONG ENDURED AND WITH PATIENCE SUPPORTED MANY SUFFERINGS."

The Sedgwick's past is a little capsule of American history. The Judge and Pamela hobnobbed with Martha and George Washington, their daughter Catherine, a novelist and the first bohemian, had Hawthorne and Melville to her literary teas, and Edie's great-uncle Babbo could remember people shouting in the street that Lincoln had been shot. Steeped in tradition, custom, habit, their past so present that the present came to seem unreal.

All of this should have bred a tribe of bright, beautiful enlightened descendants. But when you peer into the Sedgwick's musty past, their privilege and genealogy seems to have bred only intolerance and rigidity, a long uninterrupted line of crabbed and surly ancestors, their faces like slabs of New England granite, maniacs and pedants who would interrupt weddings to correct the minister's mispronunciation of words. A sorry parade and, with the rare exception of the actress Rosamond Pinchot (who ended up committing suicide), they are a monstrous outgrowth of American Puritanism, a seething mass of toxic narcissism, petty spite, and intolerance. Appropriately enough, Jonathan Edwards's manse became the haute nut house, the Austin Riggs Center in Stockbridge, where Fuzzy Sedgwick, Edie's father, was at one time an inmate as was Sweet Baby James (Taylor)—hence all those trips on "the turnpike from Stockbridge to Boston."

The Sedgwicks thought of themselves as the elect, chosen by divine providence, and the old rhyme, with a slight adaptation, might just as easily have applied to them as to the Cabots:

I dwell 'neath the shades of Harvard
In the State of the Sacred Cod,
Where the Lowells speak only to Sedgwicks
And the Sedgwicks speak only to God.

The Sedgwick's inbred genealogical dementia is represented geometrically in the Sedgwick Pie at the Stockbridge, Mass cemetery. Judge Theodore Sedgwick's obelisk stands at the center of concentric rings of entombed Sedgwicks. This theological cyclotron was so designed that at the Great Awakening, the Sedgwicks will see only other Sedgwicks as they arise from their graves and turn to face the Judge whose missile-like plinth blasts off into eternity.

Then there's Edie's father, Francis Minturn Sedgwick, curiously known as "Fuzzy." Childhood photos of Fuzzy show a delicate boy reading poetry with a wreath of laurel leaves on his head, wearing a cape of flowers. Sickly, frail, high strung, pigeon-chested, and with Cinderella feet, he suffered from a cluster of phobias: fear of the dark, water, and horses. He was ultimately diagnosed as suffering from manic-depressive psychosis and was considered effeminate even by his own mother, who thought him "sandless" (i.e., a sissy).

Through a superhuman act of self-transformation, Fuzzy willed himself into a parody of the tough-talkin', hard-ridin' cowboy, eventually moving west to California and buying a sprawling ranch that would become the location for his male impersonations. Despite all the horse-opera regalia and the Bonanza set he'd rigged out for himself, visitors to the ranch saw through the cowboy drag. He looked, said one visitor, "like one of those boot-wearing fags." Fuzzy was apparently blind to the homosexual undertones of the cowboy mythology, a strain of camp exploited by Warhol in films like *Horse* and *Lonesome Cowboys*.

When Edie was a child, the family moved to another huge ranch, Rancho La Laguna, a 3,000 acre spread. Fuzzy's compound was now his world, just as other maniacs have created their own deluded paradises to shut themselves in: Nueva Germania, Jonestown, Pullman City, New Harmony, and Xanadu (Edie's sister, Suky, compared La Laguna to Xanadu, both for its "pleasure dome" by Kubla Khan decreed, as well as its doomy "sunless sea"). The Sedgwicks even had their own schoolhouse, thus shutting off the one customary portal to the outside world. Fuzzy freezing time, stopping time, hoarding up the haunted past, a sort of Ralph Lauren fantasy of American aristocracy, the termite-ridden Puritan inheritance.

The tension of being other than he was—girly man into Marlboro Man—seems to have induced in Fuzzy a strain of viciousness and perversion that would destroy his family and end up killing three of his children. Exclusion, repression, domination, confinement, and sexual abuse warped his offspring and sent three of them spiraling to an early grave. "My father was after me since I was nine," Edie says in *Ciao! Manhattan*; in *Edie: An American Girl* she says he first tried to molest her at age seven. A truly monstrous parent, he apparently had sex with most of the girls and some of the boys as well.

Despite her father's efforts to control her, Edie grew up with a lack of boundaries, a feral child without limits physically, socially, and emotionally. She did exactly as she pleased. All the restraints imposed on the other children only bred a ferocious defiance in Edie. She obstinately refused to bend to his rules no matter what the consequences. Her mother, she just wore down.

Through her willfulness, the father's guilt, the mother's powerlessness, Edie soon had her parents wrapped around her little finger. They were helpless in the face of the tiny tyrant, whimsically acting out her own fantasies as the King's daughter. She flatly refused to cooperate however severely they disciplined her. And she never cried. Her father beat her, twisted her arm, molested her, drugged her with Nembutal and locked her up. The madwoman locked in the tower, the door to the room that can never be opened. But we all know what happens from Gothic novels and Hollywood movies; the madwoman always gets out, sets the house on fire, and brings ruin on the family.

Edie's damaged past was constantly in pursuit as she tried to outrun, outdance her cursed family. The terrible horses of the Sedgwicks gaining on her, the rattle of the doomed coach, the passengers spiteful zombies squeaking and howling, the coachman an old family retainer under a malign spell.

The La Laguna ranch looked idyllic, a manly American Eden of horses and cattle. Everything was just the way Fuzzy wanted it—and then strange things started to happen . . . Edie's brother Bobby suffers a nervous breakdown and has to be put away in Silver Hill, a genteel nut house in Connecticut. Minty, another of her brothers, finds himself in the Payne Whitney psych ward after two failed attempts at suicide: pills and jumping out a window.

Meanwhile . . . out at Rancho Notorious, Fuzzy is on the edge of his nineteenth nervous breakdown. Displaced insanity. He demands that Edie be institutionalized, and so at 19 she, too, is put in Silver Hill. Prankish and inventive, she makes empathetic little drawings of animals—her familiars—worthy of Beatrix Potter. While there, she steals her friend Virginia Davis's soul and gets away with it. In photos of her at Silver Hill—black tights, legs in plié position on her bed—she looks deliriously happy. But then, she always felt at home in the bins.

Edie was someone in headlong flight, part ecstasy, part terror. Not surprising, since the real world would always pose a danger to such a creature of fantasy. It could destroy her and had to be kept at bay. Attachments, commitments, responsibility—all the deadly leaden words that threatened to pull her down, slow her down—she threw them out the window of her troika as she galloped ahead. Faster! Faster! Avoid the webs, the ones that promised to save her but she knew were really only there to capture her. She wanted to be the spider burning in the match flame of God. To hell with the geeky godpox of Jonathan Edwards. She developed a serpentine social habit for wriggling out of things, but her brothers Bobby and Minty, poor guys, lacked Edie's agility. They were driven mad by Fuzzy's death ray. One was turned into a pillar of salt, the other killed himself in a kamikaze crash.

October 1963. Minty, clutching a bible, hallucinating helicopters, and preaching to an invisible throng, became ... a statue in Central Park. A psychosis induced by his vindictive father. Turning to stone was the only way Minty could think of to mimic the rigid male impersonations Fuzzy demanded of him. Be a man! Take it like a man! Walk like a man! Minty in his desperation would become the bronze horseman, frozen in a heroic pose no horse or cowboy ever took in life. Look, Dad, I'm a statue! I did it for you. Is this what you want?

It's said that in his psychic turmoil, Minty was unable to distinguish between himself and his father. How to get out of such a terrifying Oedipal nightmare? You could escape into a statue— no one could get at you there. If you're a statue you can't be homosexual, can you? Is there such a thing as a gay statue? Well, maybe, now that cultural historians have begun designating certain buildings as queer (the old Huntington Hartford Museum on Columbus Circle according to the

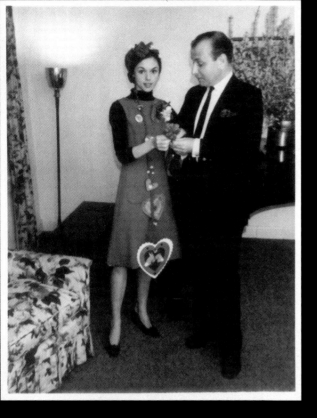

New York Times was a little light in its sneakers—fag architecture!) But, for the most part, they only make statues of long-dead queers—Leonardo, Michelangelo, Oscar Wilde—so as a statue you were relatively safe. You could pass. It would confuse Fuzzy. Fuzzy made statues. Fuzzy's favorite subject was equestrian statues of cowboys tall in the saddle. Fuzzy made statues of himself— one, incredibly enough, of himself as Christ. An astonished acquaintance once found him in his studio strapped to a cross wearing only a G-string, contemplating himself in a full-length mirror.

Minty had a problem—and the worst kind of father to confess it to. Fuzzy wasn't exactly the best person to blurt out all those latent homosexual impulses to, not the kind of liberal dad you could come home and tell, "Dad, I've fallen in love with a boy." And have the dad say, "Great, son, whatever makes you happy." No Minty, that was a death wish. There's a reason they called it "the love that dare not speak its name" in Fuzzy's day. And it was still very much Fuzzy's day.

You've perhaps heard the Theory of Exporting Unnatural Impulses onto Offspring. It's almost as if Fuzzy, wishing to dispose of the queer-loathing-in-himself (there's gotta be a compound German word for this), cast off the effeminate side of himself onto his children.

The three children in particular on whom he inflicted that detested part of himself were the gentle Minty, the unhinged Bobby, and the Peter-Panish Edie. In Minty he thoroughly hated this mirror image of himself. It reminded him of his own younger sandless self. He hated it so violently he attacked his son, knocked him down, and, in the end drove him into extinction. He had cut it out of himself and then killed it off. Bobby, on the other hand, he paralyzed with his tractor beam, flash froze him into immobility. Fuzzy the Cowboy King, old square toes, old Nobodaddy in the garden beaming his black rays from Rancho La Laguna.

Edie was another matter. Sprung like Athena from the head of Zeus, she too was an androgynous fragment of Daddy, but in a different way. She was a chip off the old block that he wanted to fuck. What could be better? It would be like fucking yourself.

They were all three locked into something they were desperately trying to escape. Gregory Corso, a friend of Bobby's and later of Edie, the old jail kid Bomb-poet recognized the squeeze-play. "They're still locked into something," he recalled in *Edie*. "I was coming from the cold of prison and these people were coming from the warmth of a six-thousand-acre ranch, but, good God, they still can't get out."

Minty, the statue boy, is taken off to Bellevue, and then moved to the infamous Manhattan State Hospital. Like a shadow in Hell, he shuffles among the pajama-clad zombies. On March 4, 1964, Minty hangs himself using a tie and a coat hanging attached to the door of his room.

Bobby is the next to go. He's already in an institution when Minty commits suicide. Bobby has also become a statue, a walking statue, a narcissist continually examining his face for traces of himself, obsessed with self-destruction, his rictus grin like the fixed grimace of Mr. Sardonicus. Taken off in a straitjacket by men in white coats.

Bobby knew Edie had the key, that in some way she was trying to show him the way out. But he lacked her quicksilver mobility. A shape-shifting sylph, she could slither out of the net. And though she saw it coming, she couldn't save Bobby.

January 12, 1965. On his bike, Bobby is trying to outrun the traffic lights on Eighth Avenue. The rush of outrunning them just as they change. It was something Edie could've gotten away with, but not Bobby. He slammed into the side of a bus—no helmet—went into a coma and eventually died. He was thirty-one. She said she felt she'd been standing on the very corner waiting for it to happen, "watching the curse play itself out in the family."

The demon was coming closer, she could feel its breath on her neck. Minty's suicide early that year had made Edie even more desperate—and it was in this state that she arrived in New York at the beginning of 1964, brought by friends as one brings a rare and exotic species to display.

She'd come from Cambridge where she'd been the center of the scene, the Cambridge princess, and where she'd first found her umah, her hive, a group of brilliant gays. "Edie loved the nitroglycerine queens and brilliant faggots," said René Ricard in *Edie*. Danny Fields, veteran of the Factory's golden years and the music business, describes these rarified coteries:

DANNY FIELDS: She hung out with Ed Hennessey, her very close friend, and Harold Petersen, a great Proustian doyenne of Cambridge. You know, bridge games and chartreuse and listening to old Helen Morgan records, and very aristocratic, brilliant, witty talk.

In desultory fashion she'd studied sculpture in Cambridge with her cousin Lily Saarinen (ex of architect Eero Saarinen), spending an entire year modeling a T'ang dynasty horse, scraping the clay off, patching it, reshaping it. That raveling/unraveling compulsion, mending the invisible flaw, were chronic speed-freak symptoms. Mercurial, changeable, impulsive Edie, seeing a shrink three times a week, picnicking up in Mount Auburn Cemetery where Mary Baker Eddy is buried with her telephone. In and out of haute loony bins and, in a perfectly surreal touch, being driven straight from the nut house to see *La Dolce Vita*.

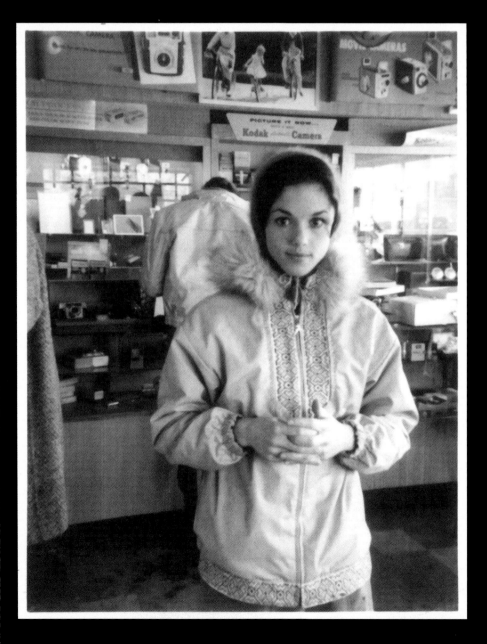

DANNY FIELDS: THEY ALL CAME DOWN FROM CAMBRIDGE IN THE MIDDLE OF THE NIGHT—I DON'T KNOW WHETHER IT WAS BECAUSE THEY'D HAD TO LEAVE OR NOT. I CAN'T IMAGINE IT WAS THE CREDITORS BANGING ON THEIR DOORS. SHE CAME ALONG WITH TOMMY GOODWIN WHO I WAS IN LOVE WITH. AND AT SOME POINT, TOMMY GOODWIN SAID, "COULD EDIE STAY HERE A COUPLE OF DAYS UNTIL SHE GETS HER LIFE IN ORDER?" SHE WAS SUDDENLY IN MY APARTMENT, A 900-POUND GORILLA, A VERY TINY LITTLE THING, SO SPOILED AND DEMANDING. AT FIRST, TO ME SHE WAS JUST A PEST, JUST THIS PESKY GIRL WHO NEVER EMPTIED AN ASHTRAY AND SAT ON THE PHONE SMOKING ALL DAY. AND SWALLOWING ALL THOSE PILLS. WE HAD TO TAKE OUR CLOTHES OUTSIDE TO MAKE ROOM FOR HERS. SHE WAS A PAIN IN THE ASS. PEOPLE WHO ARE LIVING WITH YOU AND DIRTYING YOUR ASHTRAYS AND STEALING YOUR LISTERINE, YOU'RE NOT INCLINED TO THINK HOW BEAUTIFUL OR HOW MAGIC THEY ARE—BUT, OF COURSE, SHE WAS JUST ENCHANTING AND WE WERE ALL IN LOVE WITH HER. BUT YOU KNEW SHE WAS SUCH DAMAGED GOODS BY THE TIME WE EVEN FOUND HER. BY THAT FAMILY. THAT FAMILY WITH THE FATHER WHO AS WE KNEW MOLESTED HIS DAUGHTERS AND THEN IT CAME OUT THAT HE HAD TOUCHED HIS SONS AS WELL—TWO OF EDIE'S BROTHERS KILLED THEMSELVES. THAT COULD REALLY MESS YOU UP AND EDIE WAS SO DAMAGED.

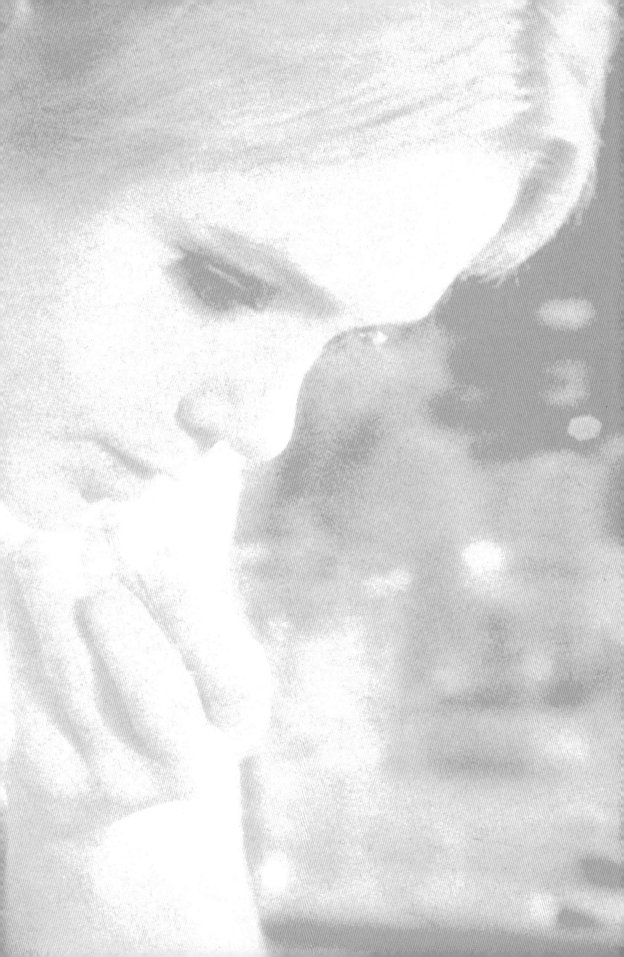

APRIL 1964

Edie moves into her grandmother's apartment, a kind of museum of fustian WASP taste, as my filmmaker sister Sarah describes it:

SARAH LEGON: It was on Park Avenue at 71st Street, a typical rambling huge old pre-war apartment with large old-fashioned canvases of naval battles and English landscapes in ornate gilt frames. Heavy, dark furniture, like our parents' apartment. The atmosphere was very dark, heavily curtained— I didn't know whether this was because of Edie's vampire hours or her grandmother's choice. Actually, I don't know whether her grandmother was still alive, but even when she was, you never saw her. She lived at the end of a hallway and was supposedly senile and never appeared.

A mausoleum of the living dead, with her senile, semi-comatose grandmother like some spectral ancestor propped up on down pillows in a darkened room. It is here in this crypt house of the dead that Edie begins her metamorphosis from Peck & Peck mothgirl (shirtwaist dresses, sweaters) into neon Edie, a black tights, black light, thigh-high-booted imp of the perverse. She emerges from the chrysalis with the emblematic peacock feather earrings and nasty boots. Black leotards, even in depth of winter. This wasn't seasonal dressing, this was the costume of the new Edie, la nouvelle Héloïse, the hellraiser.

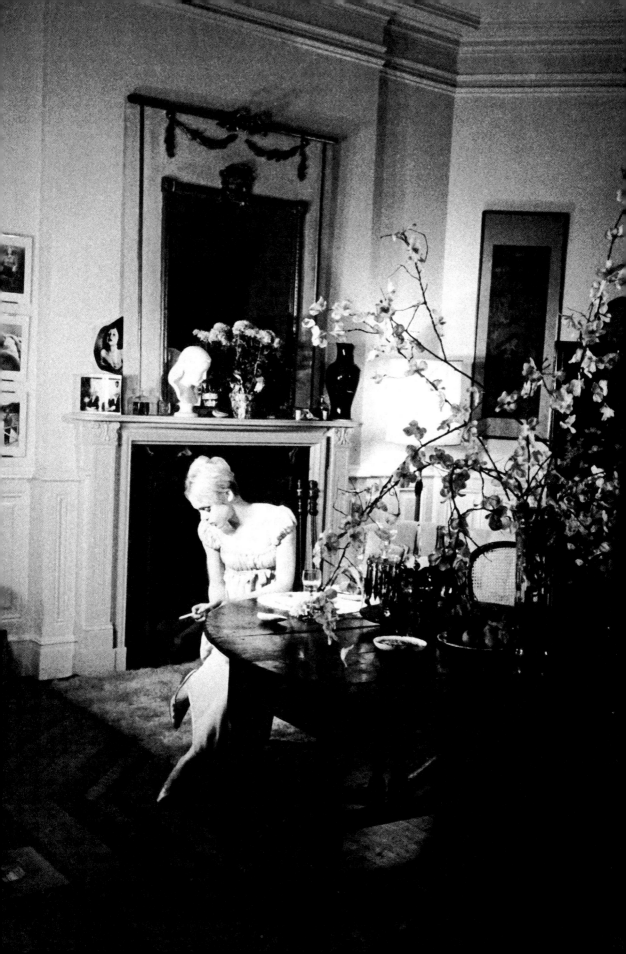

A New Jerusalem of Drugs and Rant

With Chuck Wein, Donald Lyons, and Danny Fields as her cicerones to the nouveau dens of iniquity and hipness, Edie zoned in on the hot spots, the places where the magma rose to the surface from sulfurous underground springs fed by restlessness, perversion, and amphetamine. Exquisite rooms in which hot house creatures lounged and dreamed and talked in fantastic stream-of-consciousness raps that short-circuited themselves and set off brush fires in the mind. They didn't care how many fuses they blew—self-destruction, in any case, is such a great way of getting back at your parents. Drive carefully, wear a sweater, do you have your keys?

The old values, the old uniforms had to go. It was Year Zero, dodos, get out of the way! The USA had been founded on that. NOVO ORDO SECULUM. Disposable culture, starting over, reinventing everything including anatomy. The 20th century had begun with a bang—a cluster of breakthroughs—Freud! Einstein! The Russian Revolution! Or, if you were into art, you had the *Demoiselles d'Avignon*, Kandinsky, and that old masturbator of modernism, James Joyce. The language changed, the art changed, the drugs changed, the clothes changed. And somehow the '60s had the same self-consciousness. The '60s was a decade preternaturally conscious of its need to be new and different. It was going to be the quintessentially 20th century decade, a time when all things would be made new. 1960 to 1963 was just a dress rehearsal. It wasn't until 1964 that the '60s really took off, reaching their zenith in 1967 when, dear Reader, the '60s dropped acid. Finally, and with perfect timing, the '60s took a nose-dive in 1969—like Edie burning out without so much as a fare-thee-well written on its fading dayglo forehead.

JFK, LBJ, Vietnam, moonshots, hot rocks, LSD, yippies, hippies, and pigs for president. And Edie? Edie is famous for a half-dozen Warhol films that very few people have seen—and a large number of photographs of her looking cool, beautiful, vulnerable, child-like, wrecked, etc. in what is the briefest "career" of almost any famous person. Edie would have been extraordinary even if she'd done nothing. She has become the very distillation of the idea that the self—uncontaminated by such meretricious standards as achievement or talent—is the epitome of fame. Edie is famous for being Edie.

Tick-Tock!

FALL 1964

Edie moves into her own apartment at 63rd & Madison. Scatter rugs, throw pillows, a wrought-iron lamp—very conservative, WASP taste, the only oddities a giant leather rhinoceros from Abercrombie & Fitch and on the wall a charcoal sketch of a stallion by Edie. Caviar, champagne, leopard-skin coat ("borrowed") and the famous matching leopard-skin pill-box hat.

DANNY FIELDS: We all wanted to protect her but she was so outrageously reckless. She was driving around in her Mercedes on LSD. There was so much LSD coming down from Cambridge—she kept it in my refrigerator in one of those little pill bottles, it was brown liquid. And you'd use an eye dropper to permeate the dainty sugar cubes. You know the little ones? Half of the LSD that came to New York was via my refrigerator. She would take acid and go driving and crashing. She drove into a column of the 59th Street Bridge, destroyed her Mercedes and broke her arm. Amazing that she wasn't killed.

Living on her own but still a baby. Incapable of dealing with the simplest task. Dependant on ladies in waiting, male and female alike. The limo service cradling her from place to place. Her coach idling at the curb while she puts on her lepidopterous eyelashes.

A child in other ways, too. Afraid to go to sleep, the demons could be lying in wait, slip into her brain. Her father a kind of black magician who controlled people's thoughts from a distance. The past, like a curse, radiated out of Rancho La Laguna—a laser that caused bad dreams. Even in sleep she was frenzied; her hands were never still, clawing, scratching, fending off an invisible attacker. It would catch her if she paused even for a second. All the clocks in the tower were striking thirteen. The Last Wave of the doomed Sedgwicks was moving inexorably towards her from one direction, while the future was coming at her from the other. Just that little space to act in between the two. Leap! Leap! Dance, ballerina, dance! If you dance fast enough the demons will recede. And always, hanging over everything, the inevitable price to pay.

SHE GOES THROUGH
MONTHS. EVERYTHI
APARTMENT, WITH A
MOMENTUM, EDIE M
DRAWINGS OF TINY
CREATURES, AND ST

80,000 IN SIX

IN EXCESS. IN HER

MPHETAMINE

AKES FRANTIC

MONSTERS, MUTANT

RANGE LITTLE MEN.

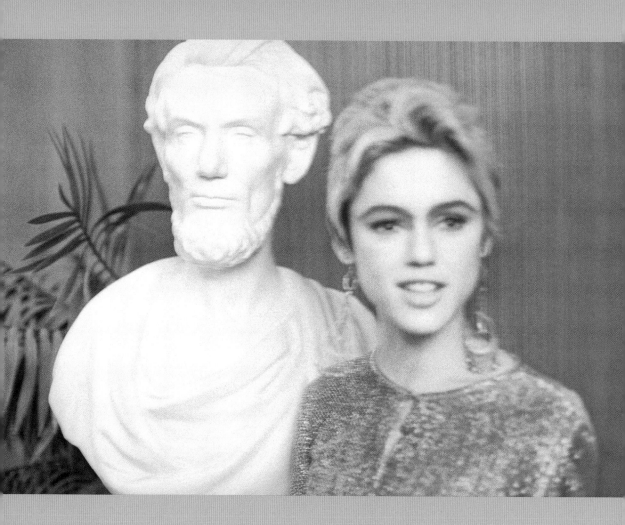

Negative Capability

"We are all doomed!" she would say blithely, but no one took this all that seriously, of course—just the apocalyptic rhetoric inherent in amphetamine. But Edie knew what she was talking about. There was incontestable proof. By the time she came to New York and met Andy Warhol there were two dead brothers lying by the side of the road, killed by a form of witchcraft that only she understood. Fuzzy was lousy with demons, crawling with psychic vermin. They were eating him alive.

Never at rest, "she believed that to sit around was to rot," Bob Neuwirth says of her in *Edie*, but it was far more dire than that. To stop would mean death. On to the next thing. Unfinished sentences, unfinished beads (stringing beads being a typical speedfreak activity), all to escape the turgid fatal goo of the past that stuck to her as it had to Minty and Bobby.

That frantic life, part hedonism, part willfulness, part outrunning the curse. Limits were there to be transcended. Limits were reality, and reality was death. A wild caged animal who from time to time sought sanctuary in the nut house. Glamour, magic, mischief—all exorcisms which would drive away the past. Against all odds!

With a sense of desperation, of things catching up with her, she entered the disenchanted circle of New York's phosphorescent nightworld to take her place as its rightful princess.

The Annunciatory Angel

JANUARY 15 1965

Future scribes of the rosy apocalypse of the '60s! Write down this date. Inscribe it in the Agarthic Record, the Domesday Book of Significant Pop Events—for this is the gossamer hinge on which the Great Wheel of the '60s turned. Actually, we're not entirely sure what the exact date was, but this is as auspicious a day as any—the day Edie Sedgwick met Andy Warhol and became the Bride of Drella, joining the other emblematic couples of the '60s: Liz & Dick, Mick & Marianne, John & Yoko, Sonny & Cher.

Andy first laid eyes on Edie at a party in Lester Persky's penthouse on 59th Street. Persky, the diabolical "Wax Queen" hustler of Roto-Broilers and Glamorene, producer of gattling-gun, hard-sell TV commercials, and lately a Hollywood producer whom Truman Capote in *Music For Chameleons* declared the ugliest, most loathsome creature on earth, the epitome of Tinsel Town sleaze and dirty dealing—and his closest friend.

Edie appears at the party in a beehive hairdo and faux-leopard suit—not the classic Edie look, but still a startling presence. Andy couldn't help notice her, despite his studied affectless haze.

Tom Wolfe had crowned Baby Jane Holzer "Girl of the Year" for 1964, but Baby Jane's star was waning. In comparison to the incandescent Edie, Baby Jane was somewhat tacky and whorish-looking and the whole thing a bit of a joke—deliberately so. Edie was the real thing—she was beautiful and a natural star. But of what?

A few weeks later Edie and Andy meet again and the infernal machinery of fame, fashion, film and infamy goes into gear. Andy recognizes at once the electric charge arcing across the room. It isn't simply that she is "a beauty," she radiates. Okay, everything radiated in those days, but still...

ROBERT HEIDE (PLAYWRIGHT): There seemed to be this almost supernatural glow to her that's hard to describe. Literally there was an aura emanating from her, a white or blue aura. It's as if Edie was illuminated from within. Her skin was translucent—Marilyn Monroe had that quality. There was an article in *Esquire* around that time on famous people, it was all somehow inter-related with death, the idea being that you could literally feel death walking alongside Marilyn Monroe and it gave off this eerie light and energy. Now whether it was the combination of pills or it was that terrible doomed quality that Edie had similar to Judy Garland's where you felt the rush of life, I don't know.

Andy, the old warlock, with his x-ray spex saw through to her core and recognized there a quark of great charm and spin. As a collector of damaged and luminous souls, he wanted to capture this rare creature on film.

Star Lust

And so, a few weeks later....

EARLY MARCH 1965

Cut to: the Factory, Andy Warhol's studio on East 47th Street. Andy, fey, feckless, and as relentless as a little Czech tank, is busy recapitulating the history of the movies in a former hat factory. He's already progressed through an early and previously inexperienced phase of movie making with *Empire*, an eight hour black & white movie that didn't move. The top of the Empire State Building shot at night resembled, if anything, early photography, the first photographs ever made.

An interviewer once asked Warhol if his movies had been influenced by film from the '30s and '40s. "No," he answered, "by the '10s. Thomas Edison really influenced me."

Warhol's first "real" movie had been *Sleep*, a six-hour film of the poet John Giorno sleeping. On this day Andy was filming *Horse*. He liked monosyllabic titles: *Empire, Sleep, Kiss, Couch, Face, Drunk, Vinyl, Bitch, Eat, Blow Job*. *Sleep* was almost as static as *Empire* but with *Horse*, movement had entered Warhol's canon. With *Horse*, which involved an actual horse, Andy was making a genuine motion picture.

In his simulation of the history of the movies, Warhol had reached the early silent era. But he was missing one essential ingredient, the one thing every movie must have: a star. The old-fashioned kind, the way they used to make them. Not the garden variety star-on-the sidewalk version. That was the very reason Andy had wanted to make movies in the first place. He was obsessed with movie stars. In the backroom of his town house on Lexington Avenue were paneled book shelves stuffed with movie magazines, gossip mags, scandal mags, one-shots, fumetti: "Sandra Dee's Dating Do's and Don'ts," "At Home With Rock Hudson," "James Dean: He Knew He Had a Date With Death!" All the frothy kitsch und quatsch of the fan magazines and the lurid exposés of the scandal sheets were there.

ANDY LOVED THE WORD "STAR"—HE U
HIS FILMS—OR RATHER THE REBUS FO
OR *THE 24 HOUR MOVIE*). IN THE FAM
WE'D ALL BE STARS—WHITE DWARFS
YOU'RE A STAR IF YOU THINK YOU ARE!
FREQUENTERS OF THE FACTORY IN VA

STARS AS THE TITLE FOR ONE OF
HE WORD: ★★★★ (AKA *FOUR STARS*
S-FOR-15-MINUTES PHILOSOPHY,
THE EVENT HORIZON, BUT STILL.
S WAS ANDY'S CREDO, AND ALL THE
NG DEGREES ASCRIBED TO IT.

Andy dwelt on the mysteries and peccadilloes of the stars in a truly obsessional way. He worshipped everything about them, including their feet. Their toes. The anatomical extremities of stars had a magical attraction for him. Mad Andy spying Bette Davis in a restaurant, rushing in and begging her to let him draw . . . her feet. And then that alarming scene on Madison Avenue in the middle of the afternoon. A balding man (this is pre-wig Warhol) with albino-white skin on his knees asking a famous movie star for something mildly perverse and vaguely threatening. But to Andy even a rebuff from Bette Davis would have felt like a blessing. Astonishingly, a number of movie stars agreed to let him draw their feet—he made a little book of them, all lettered in careful apostolic script by his mother.

"Gee, I wonder how stars get made?" Andy would ask. "Where do they come from?" even though he knew in excruciating detail the answer to these wistful questions, the sordid stories from Hollywood Babylon, the scaly truth behind the overnight discoveries.

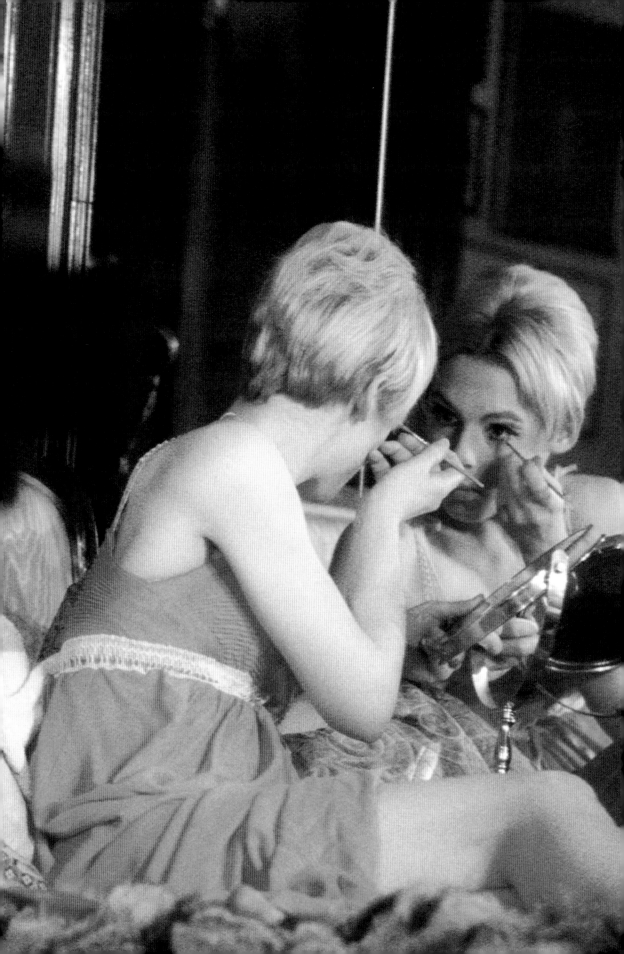

A Catholic who went to church every Sunday, albeit briefly, who lit candles for saints, who prayed to the Virgin, Andy was predisposed to believe in metabeings and miracles. In angels, in statues that wept and bled, in appearances on earth of celestial beings—to the peasant children at Lourdes. All this meshed, leaked into his theology of movie stars. Were they recognized as stars at birth—the way a new Dalai Lama is found by certain signs and recognitions? He had read all the movie-star books and knew just the opposite was true. The terrible childhoods, the gangly, Ugly Duckling adolescences, the frustrations and humiliations on their relentless climb up that starry ladder—and then! Could one tell a star from a normal, average, every day person? Well, of course. That was the mythology of Hollywood: the future starlet discovered at Schwab's drugstore. A studio head, a producer, a talent scout just happened to walk into Schwab's in the middle of the afternoon and order a malted—and there she was! Lana Turner!

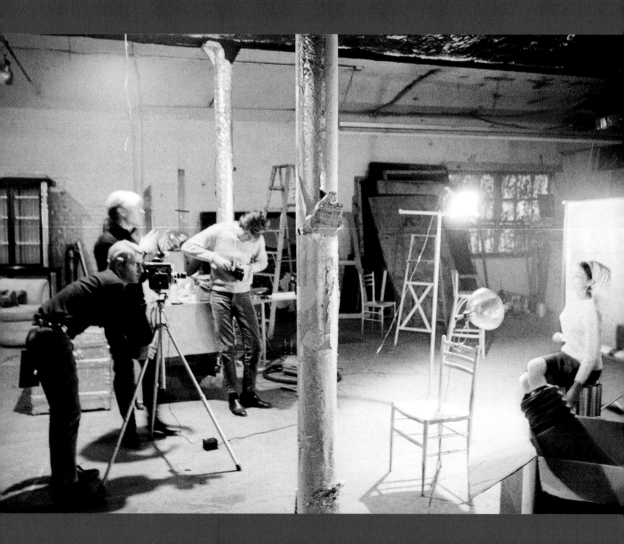

Tinfoil Palace

The Factory was a camp version of Schwab's drugstore, a place where everyone pretended to be a star. And, of course, in the Copernican universe of the Factory, eventually everyone was. Andy's glittery fame fell on every last one of them.

At that point in time—early '65—just being in residence at the Factory revealed you as one of the elect. Almost everybody who hung out at the Factory was exceptional in one way or another. If you weren't, you didn't last too long. And while it was a charming conceit to think of oneself as a star or superstar, it was just a game. In comparison to the classic stars of Hollywood, these folks were a joke. Gerard Malanga, Andy's assistant, was "a beauty," according to Andy—and goofily vain, posing and preening. Even while smoking a cigarette he looked as if he were posing for a statue by Bernini, but Gerard was no movie star.

It was a make-believe movie studio. Factory Features. Warhol was the studio head, producer, director, casting agent, distributor, and publicity agent all rolled into one. It was an efficient system, and the best thing about it was that you didn't even have to be particularly talented at anything to be in one of his movies. You just had to be there—and have something a little, well, quirky about you.

Given the loopy nature of this enterprise, the amazing thing is that some real stars did emerge from the dream factory on 47th Street—Edie Sedgwick being, after Warhol himself, the best known of these, and in Edie's case all the more remarkable because only a handful of people have ever seen her movies. Some of them can't be located to this day, but the stills from "the making of" these movies are absolutely tantalizing.

Through photographs of the Factory, a world of immaculate hipness and cool is revealed. You don't need to see the movies—they are in most cases exercises in Dada histrionics, deviant sex, and impenetrable scenarios. Many written by Ron Tavel with exquisitely banal, surrealist lines—that the actors, for the most part, were too high or bored or peevishly narcissistic to remember. Continuity or plot? Of course not—the lack of these being the point. Any moron can write or direct your average Hollywood movie—and does—but it takes genius and an inspired haphazardness to make an Andy Warhol movie.

Knock! Knock!

The cinéphile clan of the Factory, idolaters of Greta, Judy, Marilyn, Kim, and Liz awaited the coming of the One Foretold, the long-anticipated appearance of the sphinx-like diva, the uncanny element in the periodic table that would light up the brightest heaven of invention. Like Micronesian islanders expecting the arrival of some fantastic and macabre goddess, the denizens of the Factory had built their own version of a cargo-cult plane out of sticks and twine. They had the camera, the lights, and all the paraphernalia of the movies. With infinite patience they waited for the unexpected and inevitable appearance of the star.

The wobbling, moaning, screeching of the freight elevator ascending to the Factory was like a donkey's trumpet announcing the Last Judgment. The metal gates pushed back with the clanging sound of Marley's ghost. Not Bob Marley, of course, but Jacob Marley, Scrooge's ghostly business partner in *A Christmas Carol*. If Marley's ghost had come up in that elevator dragging his chains and howling, nobody would've turned a hair. That elevator was Marley's ghost. Or the New York equivalent, old Mr. Zornkopf, owner of the former hat factory sweatshop, bewailing his fate in Yiddish. It was haunted, that infernal contraption, and even the most vociferous ghost couldn't be heard over the blaring music. If Jacob Marley and his chains had appeared, Andy would just have put him in a movie.

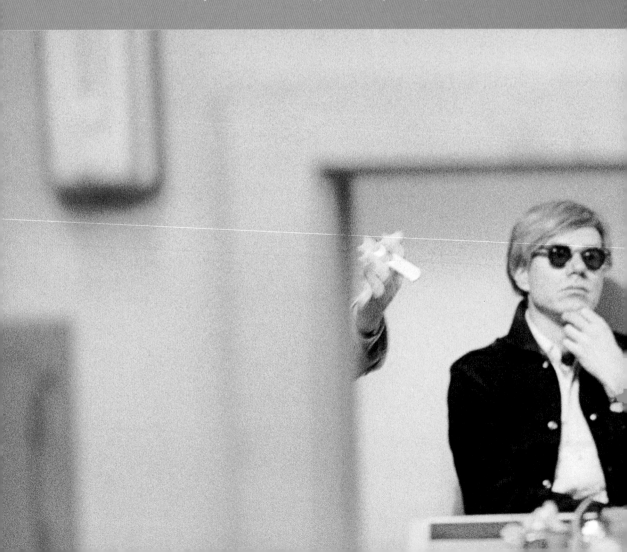

As the great clattering freight elevator arrived at the fourth floor, heads would swivel with jaded interest to see what entertaining new curiosity the rattling cage would disgorge. Somebody interesting, to be sure, because at this point in time the Factory was not yet on the general kulturputsch, where every vaguely hip doctoral candidate, decadence hound or mid-western Gasket King felt it to be a necessary stop on the Grand Tour. Back then, towards the beginning of the Andy Warhol Story, they were always awaiting the arrival of somebody fabulous, some movie star or rock star, some slumming aristocrat or pretty boy. Really, anything could happen—and did—at the Factory.

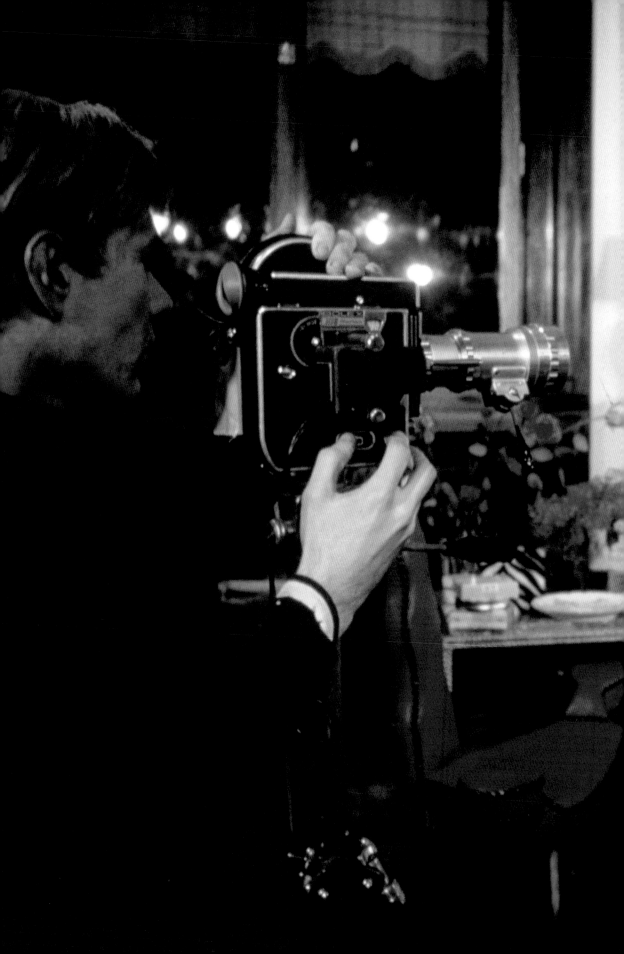

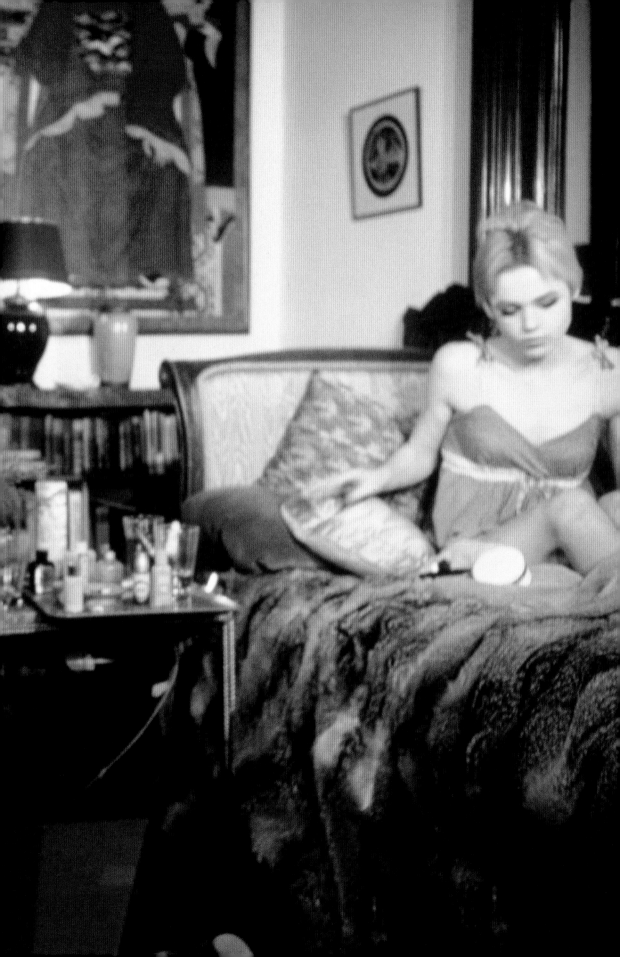

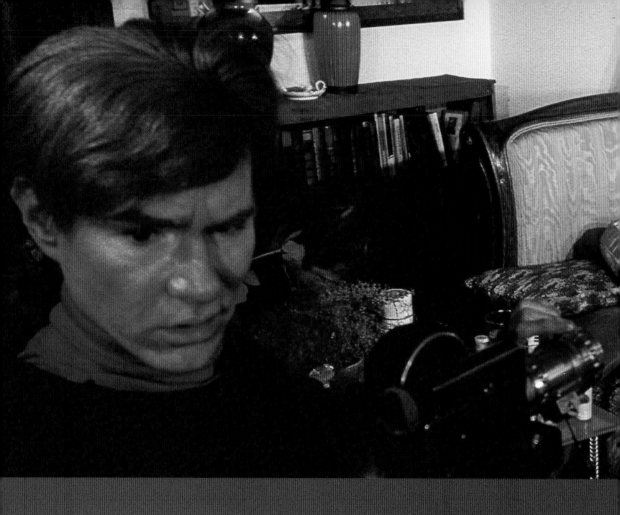

Lights! Camera! Edie!

The Factory was a stage set. Entering from those metallic gates, you were expected to perform. Someone's always on the phone, the silver phone. An entire novel, a, was written on that phone. Sort of. They gave Ondine (Bob Olivio) four Obetrols, and he and assorted Factoryana talked for 24 hours straight (that was the illusion, at any rate). Billy Name (nom de guerre of Billy Linich—photographer/metaphysician, resident gnome of the Factory):

BILLY NAME: In our day, Ondine and I were happy to slice everyone up, but we were just doing it because we were so clever and high that we could. It was like baking a cake or something. We were just showing off. People would run from us in horror, as we later heard. They would walk in the Factory, sense what was going on and fly away out of there. It always had this feeling of peril. I mean there'd be Ondine shooting up in the back or Bridget poking herself in the butt, and Maria Callas screaming away on the turntable. So it was not a place where ordinary people, or even aspiring people, would go and expect to be well treated. And if you didn't have a strong ego or a strong character you were going to be offended and hurt.

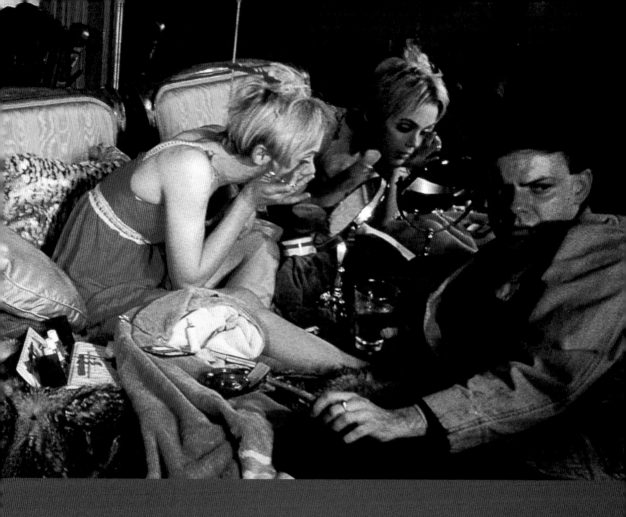

Silver foil, silver chairs. As if King Midas, from the duchy of Woolworth's, had passed through and touched every object in the room, every wall. Silver for the silver screen, silver for the silver '60s, silver for silver Andy.

The denizens of the Factory might be asleep on the couch, talking on the phone, shooting up in the bathroom or dancing to "My Guy" played at deafening volume—nevertheless, you had to be ready for your close-up. It was like arriving at Versailles or at the court of Queen Elizabeth. A little respect, please! You are entering an exclusive club for misfits, gay speedfreaks, would-be Adonises, and walking skeletons. A sort of halfway house, halfway up to the sacramental fog of a Desoxin high or halfway down to Hell, it was up to you.

And then—that very day—in walked Edie, with Chuck Wein: blond hair, green eyes, like a surfer, but from Cambridge, Mass. Chuck, self-possessed, aware of his own attractiveness, a whiff of entitlement from the elite crowd he and Edie hung out with in Cambridge. Nothing phases him, and, why would it? Look who he's with.

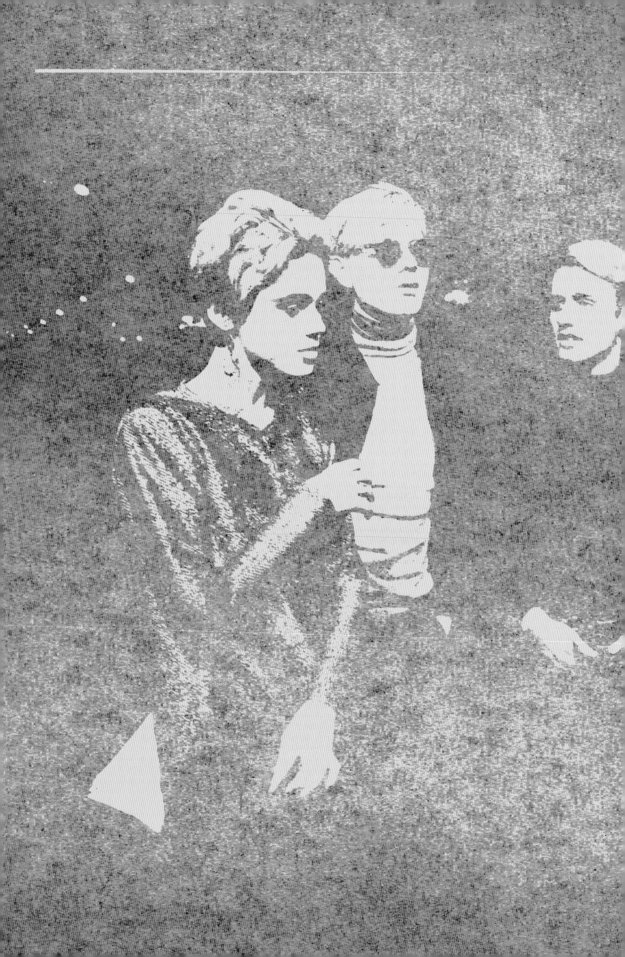

EDIE ENTERS THE FACTORY IN
HER OTHERWORLDLY DAZE.
SHE IS AT ONCE NATURAL AND
A CREATION OF PURE ARTIFICE.
EVERYTHING ABOUT HER—HER
TIGHTS, HER LONG LEGS, HER HIGH
HEELS, HER PRETERNATURALLY
SKINNY BODY, HER HUGE EYES—
SEEMS TO DRIFT UPWARDS AS IF
THE CIGARETTE SHE IS SMOKING
WERE MADE OF HELIUM.

Horse Operetta

The elevator groans, the gates open. Once again it's Allan Kaprow! Princess Radziwell! The very Allan Kaprow who invented the Happening and, well, you know Lee Radziwell.

ALLAN KAPROW: I went to the Factory for the first time with Lee Radziwell. We went up in that clanking elevator, like a cage taking you to Hell, and when we opened the door to the Factory, there was a horse pooping right in front of us. Lee and I shrunk from it. Then we saw there was someone on the floor with a movie camera catching the poop on film as it came out. Andy, who was standing next to the boy holding the camera, paid no attention to us at all. He just said to the boy in a very bored tone of voice, "Did you get that?" and walked away without listening for his answer. The place was blaring rock 'n' roll. Edie Sedgwick was all over the place, posing and making herself obvious. In a high pitched whisper she said to the air, "The princess has arrived," and then repeated it over and over in a manic rhythm to the music, a chant: "Theprincesshasarrived, theprincesshasarrived, theprincesshasarrived, theprincesshasarrived," as she twirled round and round like a mechanical ballerina. Andy looked up and saw us and said, "Oh, gee, how nice of you to come," as if nothing had happened.

A Hollywood Western backdrop was set up for *Horse*—and then dismantled. "Gee, it looks too much like a real Western, don't you think?" Andy whined. He wasn't making a Hollywood movie, he was making a grotesque parody of a Hollywood movie. From the standard Hollywood model, he siphoned off the most provocative implications. In *Midnight Cowboy*, the Dustin Hoffman character tells Jon Voight, rigged out in cowboy gear, "that's fag shit." So naturally, that would be the direction he'd want to go in. The themes of *Horse* would be: homos on the range, gay cowboys masturbating and engaging in bestiality and gratuitous violence. By this point in history, and way before *Brokeback Mountain*, it was well known that the actual Marlboro Man was gay. The theory of exaggerated masculinity: sailors, cowboys, cops, bikers (the Village People, essentially) said that anything too over the top turned into its opposite—it was a law of inverse sexuality. Whatever was too macho had come to seem just butch or rough trade. This was especially true of the Cowboy, the quintessential icon of America's puffed-up self.

BILLY NAME: The horse movie was totally awkward and gawky and ridiculous. And the guys didn't know their lines. We had Gerard and Tavel holding up cue cards for them just as in *Vinyl*.

On the set of Horse a sign is held up to direct the actors to their next bit of business. "APPROACH HORSE SEXUALLY." Even your practiced Method actor might balk at a stage direction like that, but not the Factory cowhands. They knew just what to do. The slumming Hollywood starlet and the giant donkey dick were part of the Factory's fairy tales. But the horse doesn't react well to this kind of intimacy—it barely knows these guys, it has standards. It lashes out, kicking Larry Latreille in the head. He's bleeding, almost comatose on the floor. Do they huddle in concern over their fallen comrade? Of course not. Violence, once initiated, is catnip to these guys. They beat Larry Latreille to within an inch of his life.

A (Super) Star Is Born

Andy knew exactly what to do with Edie. In early March, he gave her a walk-on in *Vinyl*, which initially pissed off Gerard—poet, actor, and Andy's art assistant at the Factory:

GERARD MALANGA (IN *EDIE*): In *Vinyl* I was giving my juvenile-delinquent soliloquy when Andy threw Edie into the film at the last minute. I was a wee bit peeved at the idea because it was an all-male cast. Andy said, "It's okay. She looks like a boy." She had covered her automobile-crash scar with a decoration like a teardrop. She said something you could hardly hear on the soundtrack. Otherwise she didn't say anything.

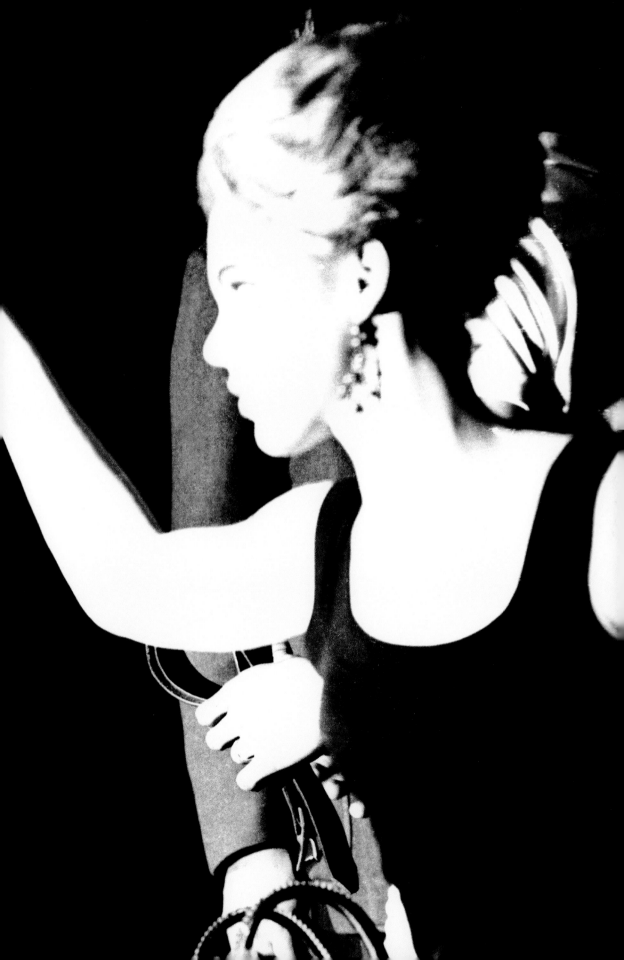

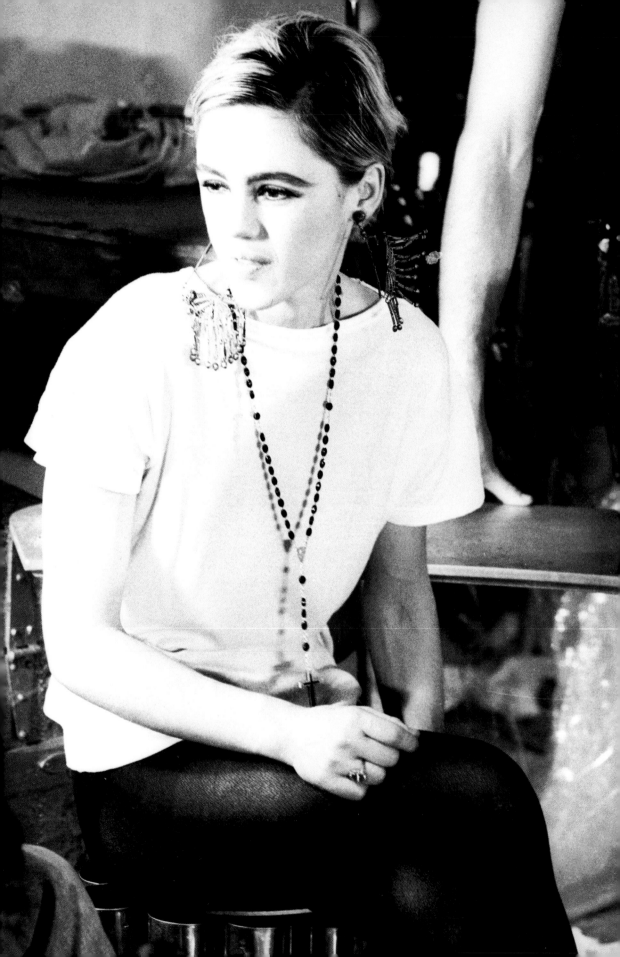

ike most of Andy's pre-Paul Morrissey films, *Vinyl* is a series of sexualized cinematic tableaux, a voyeurist's desire to freeze-frame the moment. It took filmmaker Chuck Wein, Edie's friend from Cambridge, a moment to grasp Andy's aesthetic.

K WEIN: Who knows what Andy wanted? It was to prove that we otally anti-social with everyone else. More like, let's give them this v them there's no big deal. We had that discussion; I'm just bering that now.

Vinyl is typical of what Stephen Koch in *Stargazer* calls Warhol's "fertile carelessness." The actors were not only unrehearsed—Andy insisted they not rehearse. There's not even a pretense at memorizing their lines; they are seen reading their lines off cue cards.

The true revelation in *Vinyl* was the arrival of Edie—as Ondine (Bob Olivio), the Factory's philospher prince and prime ranter, noted.

NE (IN *EDIE*): Well, after we saw a few reruns of *Vinyl*, some of an inkling of what was going on there with her in the Factory . . . r that we hadn't expected.

Ron Tavel's scripts in any case were quite malleable—and frequently discarded (memory lapses, willfulness, change of plans). This was the underlying principle of Andy's movies: presenting nteresting, desirable, grotesque, goofy, and fabulous people on screen in nonsensical plots. Nothing mattered but the Appearance, in theological terms, the parousia, a "presence" revealed 2 Corinthians 7:6), a showing of the self (in the case of a Warhol movie, essentially just showing up). No editing, unless it was necessary to make the film look unedited. When my sister Sarah edited *Sleep* at age 14, Andy told her that if she saw anything interesting to cut it out.

n *Vinyl*, Andy puts her on a big silver trunk, smoking incessantly, her long black-stockinged egs dangling over the side. A crew of professional S&M fetishists having been imported for the occasion to give the torture scenes an authentic touch. Poppers, amyl nitrate the air crackling with short-circuited synapses.

A walk on was all she needed. Warhol found her fusion of artifice, effortless grace, and mischief rresistible. Like the lovesick student in E.T.A. Hoffmann's "The Sandman," who lost his heart to the mechanical doll, Olimpia, and brings her to life with his own animating-fluid, Andy anointed Edie his otherworldly bride, put her on the stage of his mock theater and preserved her like some

The Barbarian Invasions

At this point, the listeners—sitting by a flickering chemical fire in the post-apocalyptic wasteland—interrupt the tale teller. How is it, they ask, that our freakish forebears, Andy Warhol and Edie Sedgwick, came to represent the First Great Silver Age when all around them the straight, drab world of the '50s still prevailed, a world of men with crew cuts and three-piece suits and three-martini lunches and madras shorts and rotisseries and necrophiliac dinner parties on Park Avenue? A world in which men and women were cruelly trapped in a John Updike novel?

Patiently the ancient mariner explains how the long-foretold transformation came about . . .

New York society was in a state of flux. The barbarians were at the gates! Long-Island multimillionaires, Jersey guys—Jay Gatsbys with no intention of adapting to the stodgy fun of café society were pouring into town. They weren't even gonna try and shoehorn their big feet into the glass slipper. Fuck that shit! Brash, loud guys from the Five Towns with their shrill bouffant-wearing wives blew onto the scene. NOUVEAU RICHE—AND PROUD OF IT!

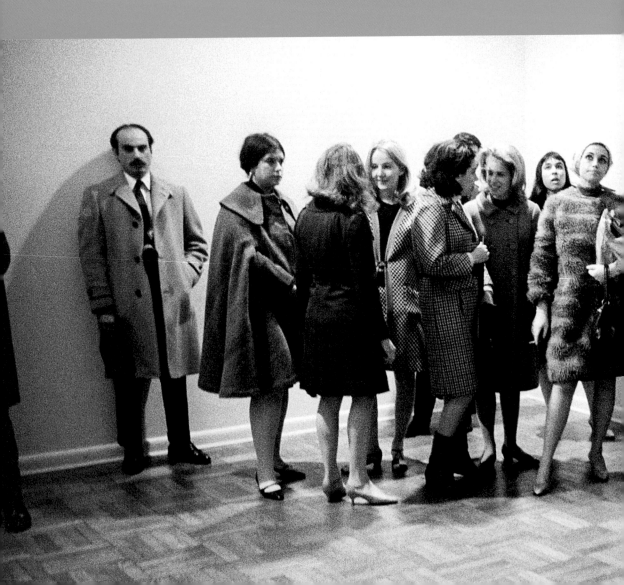

The New Vulgarians sought out anything new and weird—anything to épater the old farts! They loved crazy artists, were devoted to the flamboyant camp of Pop art. Even if they occasionally chose artwork to match their sofas, so what! They wore loud suits, too much jewelry, flaunted their big bucks and were going to have a good time——to hell with all those old WASPs and gentrified Jews. Dinner for fifteen and then everybody in limos to watch porn movies in Times Square—now that was fun. They were a sorely needed infusion of energy and they had a nose for anything new and freaky.

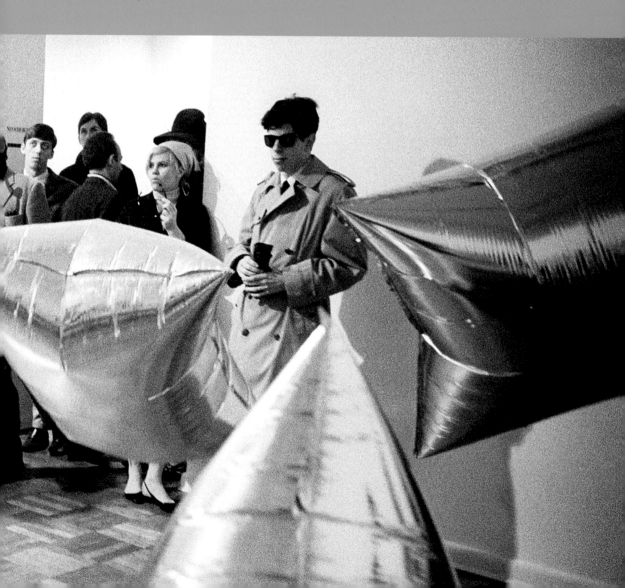

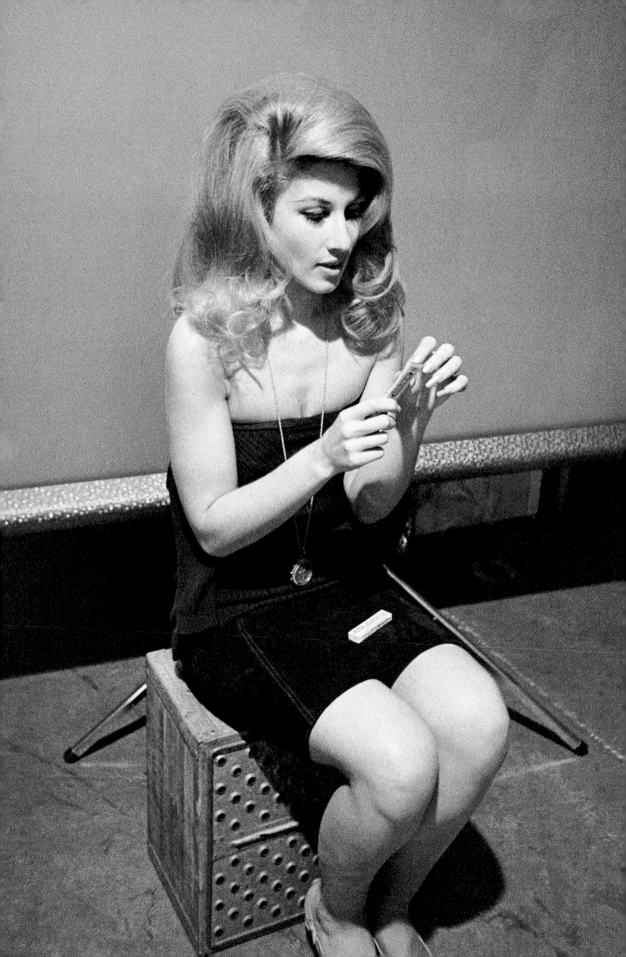

Mutant Spawn

And it was just at that point that a new crop of mutants appeared on the scene. Downtown were the neo-Beatnik hipsters (Bob Dylan, Bobby Neuwirth, et al), and midtown was the alien tribe of Warhol's Factory. The vulgarians, as if lifting up the lid of a dayglo Hell, had exposed the Albino King and his weird court to the light of day and quite suddenly the velvet underground of New York's gay, speed freak nightworld was all the rage. Baby Jane Holzer (pictured left), who came from a well-known real-estate dynasty, had appeared in Andy's risqué movies and hobnobbed with yobby Brit popstars. Her name was mentioned in all the gossip columns along with Andy's. Andy was odd—but charmingly fey—and, as things tend to happen in New York, he was embraced as a genuine type you'd find nowhere else. Like alligators in the sewers, New Yorkers prided themselves on breeding oddities and eccentrics. Andy was the first painter since Jackson Pollock to conform to the public's image of the crazy artist. Cab drivers and guys delivering your refrigerator knew who he was—the Campbell's Soup can guy.

The world had turned upside down overnight, the result of unprecedented sunspot activity, the Age of Aquarius, too much fluoride in the water supply, extraterrestrials—whatever the cause, suddenly freaks were the new aristocracy. Spectrally thin, with alien bodies, they lived on powders and synthetic potions.

Pop art, and especially Warhol's Campbell's Soup cans, at first generated a lot of negative criticism. This thrilled Andy. "Gee! *Time* magazine's putting me down!" The art critics called it a mockery, a celebration of American vulgarity, but the public loved it. It may have seemed nothing more than a novelty, but after the portentousness and opaqueness of abstract expressionism it looked like fun. And anybody could get it.

"It took intelligent people years to appreciate the abstract-expressionist schools," Andy told the *London Observer* in 1966, "and I suppose it's hard for intellectuals to think of me as Art. I'm a mass communicator."

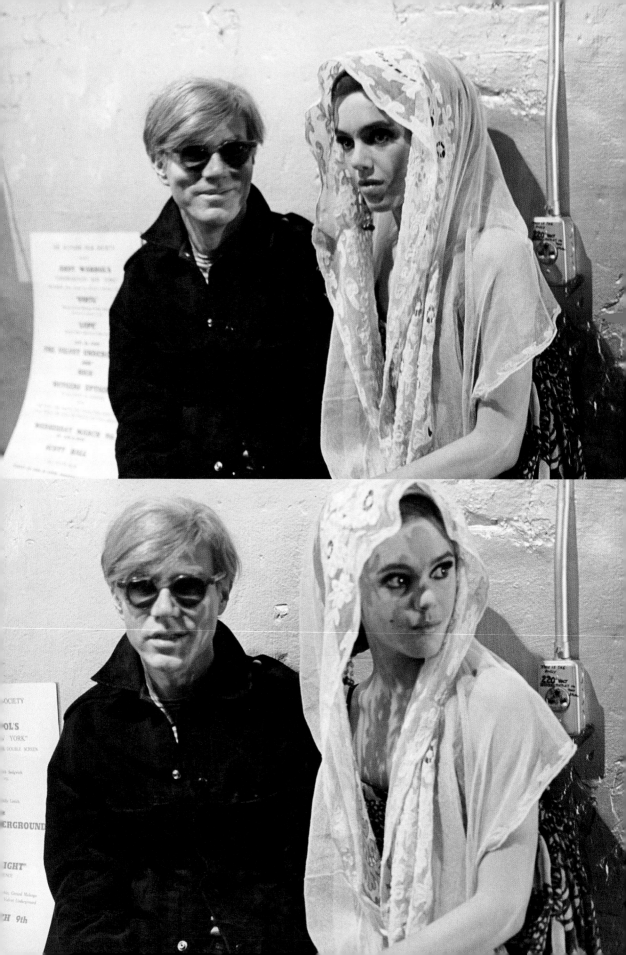

Cinderella and Drella

Fame (and infamy) had forced Andy to become a social creature. Of course, he wanted fame, wanted it more than anything, but he was an unlikely candidate. Socially inept, shy, and timid, with his ectoplasmic skin, his bulbous nose (even after a nose job), and that fright wig, Andy was freakish-looking and ill at ease in public. In the early years he didn't even like to eat in public—and he had a horror of being touched. As if on cue, Edie appeared, arriving from another, more glamorous world, and unlike Andy, Edie was madly social.

ROBERT HEIDE: She transformed him. Andy before that was sort of a very grubby dresser. Most of the time in the early days, he was not so dressed up. I remember him in a pair of dungarees at the Factory with a hole in the back and his bare ass showing, so maybe it was Andy who started that trend of the ripped and torn designer jeans! He always wanted style but he didn't know what style was. Later on, particularly after he was shot, he became piss elegant. But before that he was always a little ragged. Edie had an impeccable sense of style—with those long legs and the little striped shirt—she invented that shirt, by the way, it wasn't Andy. She came in with that. He took it on as part of his fashion statement, because, as you know, Andy was a great absorber.

Andy forced himself to become the opposite of his natural inclinations—in Warhol's case a social creature. The mad public life that he both loathed and relished, counting the inches in gossip columns with an accountant's single-mindedness, began with Edie. Paired with Edie—the two of them with identical hair and outfits—Andy was a far more palatable social entity. The appearance of the silvered twins in public created foolishly giddy speculations in the gossip columns. Which was which? What sex were they? What did it all mean? The transference of gender and identity between the two of them as they went about reinventing their public personas magnetized a huge amount of energy. They were a brilliant folie à deux.

ROBERT HEIDE: Edie tried to do her hair exactly the same color as Andy's. A lot of times it would be blond, but this particular night it was silver. Andy was very enamored of that picture of Truman Capote on the back cover of *Other Voices, Other Rooms* with the hair falling into the face. Andy was obsessed with Capote—he had his wigs designed so the bangs would fall over his forehead so that he could push the hair back just like Truman. The tragedy is that I would later see Truman at Studio 54 with Andy, and Truman by that time was falling apart, really falling apart. And there was Andy glorifying in this image of himself and on the other side of him is this fat old desperate man who is killing himself with alcoholism and drugs.

TRUMAN CAPOTE BELIEVED
EDIE, WOULD'VE LIKED TO H
WAS, A BEAUTIFUL, ARISTOC
SELF-POSSESSED THAT PEO
SHE ENTERED THE ROOM AN
ON SIGHT. "HE WOULD LIKE
ANDY WARHOL," SAID CAPOT

AT ANDY WANTED TO BE
E BEEN EVERYTHING SHE
ATIC GIRL, SOMEONE SO
E'S HEADS TURNED WHEN
WHOM EVERYBODY LOVED
HAVE BEEN ANYBODY BUT

A Most Divine Mixture of Horrors

In *Vinyl* Edie had been on screen for less than five minutes, but that was enough. Andy—and everybody else at the Factory—recognized Edie's qualities as soon as they showed the film. Edie illuminated the Caravaggio-like S&M sequences. However wrecked, hung-over, and wasted she was, the camera swooned over her in the same way it had over a young James Dean. "Maybe his [movie] father doesn't love him," the critic Pauline Kael wrote of his first movie, *East of Eden*, "but the camera does . . ."

Warhol and his crew had the griminess and the seediness down, and into this darkness and depravity came Edie, her incandescent beauty a perfect foil to the kinky noirish tone of the film. She had entered the murky fairy-tale nimbus of the Factory the way the Angel Gabriel alights in darkened chambers in Early Netherlandish paintings.

BILLY NAME: Edie so easily made herself part of the scene. She was like a piece of the jigsaw puzzle that was missing and just snapped right in; it wasn't really necessary for me even to think about it. Edie just came in so gracefully and became part of the whole thing. And we became very good friends. Easily, you know. It was just so easy for her. We would talk about the state of cosmology and all these scientific crazy things that always parallel the arts. That's the kind of mind she had. Brilliant.

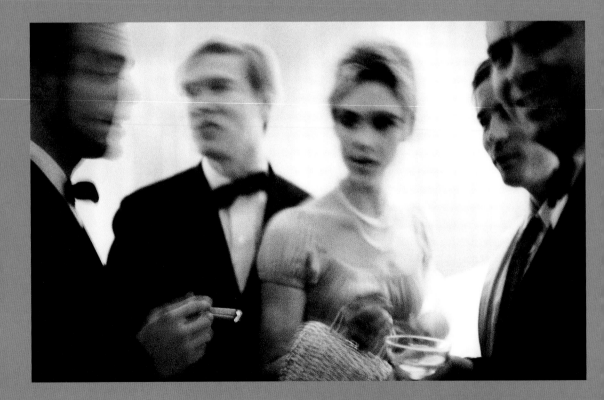

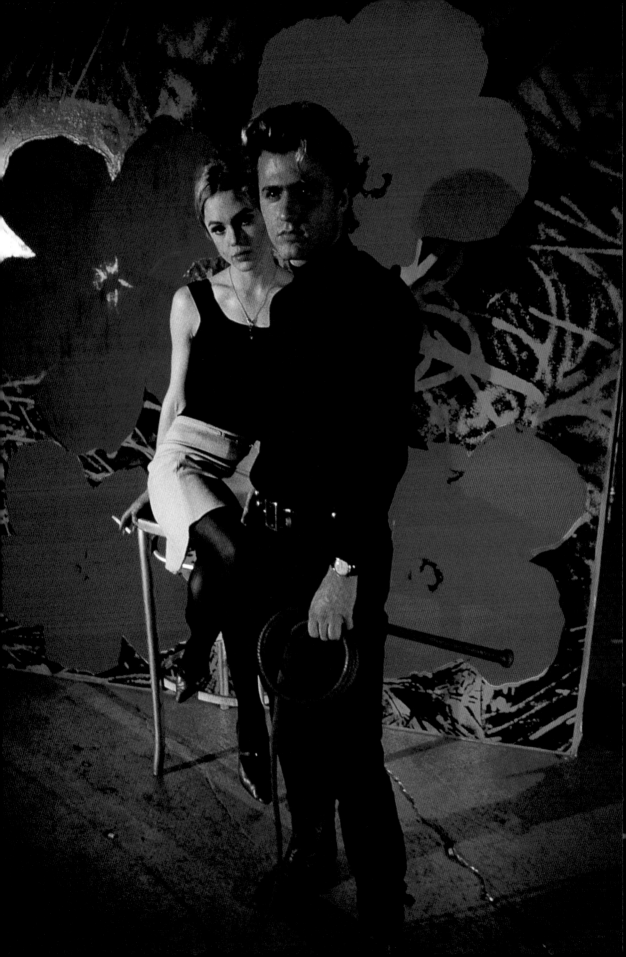

Changing of the Avant-Garde

Edie's Cinderella moment came at the party Lester Persky threw at the Factory in the spring of 1965 for the Fifty Most Beautiful People. Edie, seen here in this photograph by David McCabe, was the new star, the superstar, a new emanation for the new epoch, and, without doing a thing, except being her luminous self, she outshone the brightest stars of old Hollywood.

The elevator gates opened and Judy Garland appeared, carried on the shoulders of five boys, like Cleopatra in a Hollywood epic. Rudolph Nureyev danced with a Russian sailor, Tennessee Williams sipped from a hip flask and wondered what the hell he was watching. A man was violently shouting at him from the screen about an appliance he must have! Was this an Andy Warhol movie? No, it was one of Lester Persky's terrifyingly belligerent hard-sell commercials— which Andy at one point planned to insert in a film about Persky called *Soap Opera*. Edie and Brian Jones compared notes on their speed doctors. Edie's nouveau hipster Dr. Robert and Brian's Nosferatu-like Dr. Jacobson lurking in his medieval catacombs with Jay Lerner trying to write another hit show between shots of vitamin B and Methedrine. Also at the party were the last two members of Beatnik glory, Allen Ginsberg and William Burroughs talking about Tangiers and royalties. And over there, skulking in a corner, was Montgomery Clift, hunched over, resembling an aging, accident-prone Raskolnikov with a bottle of scotch.

ROBERT HEIDE: One image I have of Edie is at that party… dancing, dancing, dancing, just kind of whirling and twirling. I was a little spaced out myself but I remember thinking, When is she going to stop? What is she on? It was sort of like one of those dolls that spin out of control.

Gods were at that party, but as Gerard Malanga later crowed, "There were more people staring at Edie than at Judy." It was the night when the old stars of Hollywood went out and Andy's superstars came in—and given the heady high spirits and enough artificial energy you could really believe it. Judy Garland, in any case, had long been a parody of herself, and as she and Nureyev descended together in the clanking elevator and out into the glare of early morning, she yelled at the non-plussed Russian dancer, "You filthy commie spy, you!"

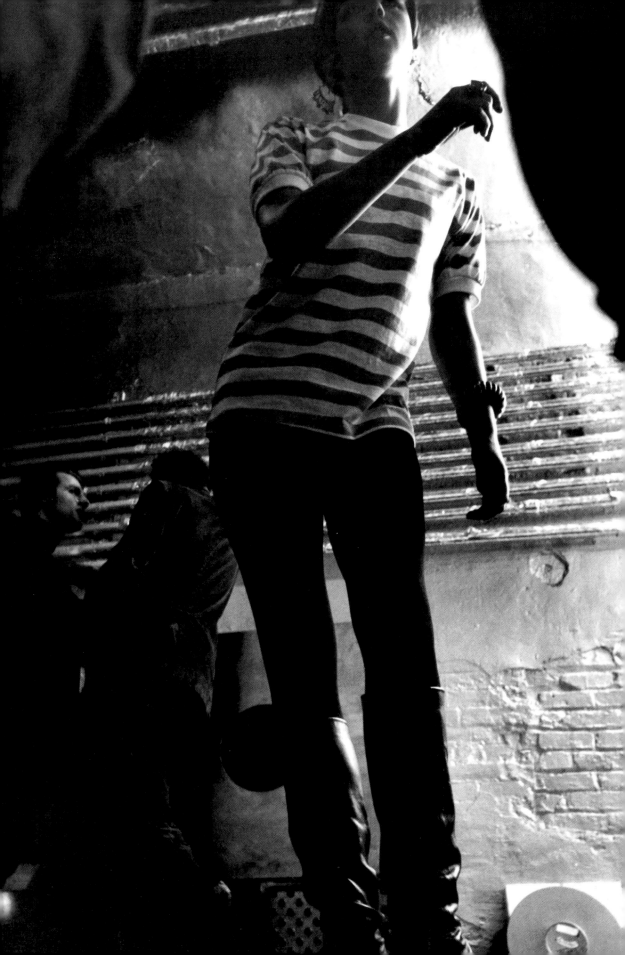

NAT FINKELSTEIN: I WAS AT A PARTY AT THE
HUNTINGTON HARTFORD MUSEUM. I SAW
JEANNIE KRASSNER STANDING BY HERSELF
DEEP IN THOUGHT—OR SO IT SEEMED. I WALKED
OVER AND ASKED, "WHAT ARE YOU THINKING
ABOUT?" SHE SAID, "SEX." "YOU WANNA FUCK?"
"YES," SHE SAID, "BUT CAN WE FIRST STOP OFF
AT THIS PARTY AT ANDY WARHOL'S STUDIO?" IT
WAS THE 50 MOST BEAUTIFUL PEOPLE PARTY.
A FEW DAYS LATER I WENT UP TO THE FACTORY
AGAIN. ANDY CAME OVER AND SAID HELLO.
HE KNEW MY NAME FROM THE ARTICLES ON
CLAES OLDENBURG THAT APPEARED IN *PAGEANT*
AND *PLAYBOY* FOR WHICH I'D DONE THE PHOTO-
GRAPHS. I ASKED ANDY IF I COULD TAKE A
COUPLE OF PICTURES OF HIM. I BROUGHT THE
PRINTS BACK TWO DAYS LATER AND HE SAID,
"WOULD YOU LIKE TO COME AROUND AND TAKE
SOME PHOTOGRAPHS?" "SURE," I SAID. THEN,
COINCIDENTALLY, A DAY LATER THE *LONDON*

OBSERVER CALLED MY PHOTO AGENCY AND ASKED IF THERE WERE ANY PHOTOGRAPHERS WHO KNEW ANDY WARHOL. AND THAT'S HOW I GOT INTO IT, MAYBE THE SECOND OR THIRD DAY I WAS UP THERE EDIE CAME WANDERING IN. SHE WAS WEARING A BELGIAN LACE SHAWL OVER HER HEAD. ANDY INTRODUCED ME TO HER AND SAID, "COOPERATE WITH THIS GUY HE'S GOING TO MAKE YOU FAMOUS." THAT DAY I SHOT THE PICTURES OF HER WITH THE SHAWL OVER HER HEAD. THEY WERE VERY PRESCIENT BECAUSE I SAW DESTRUCTION THERE—WHICH IS WHY I PHOTOGRAPHED HER WITH THE SHAWL COVERING HER FACE AND THE LIGHT COMING THROUGH. THERE WAS JUST SOMETHING ABOUT IT. THIS IS DESTRUCTION, I THOUGHT. YOU LOOKED AT HER AND SAW EXTREME SELF-DESTRUCTION—THE WAY SHE CLENCHES HER HAND ALMOST LIKE A CLAW. SHE WAS OFF ON THE ROAD TO PERDITION.

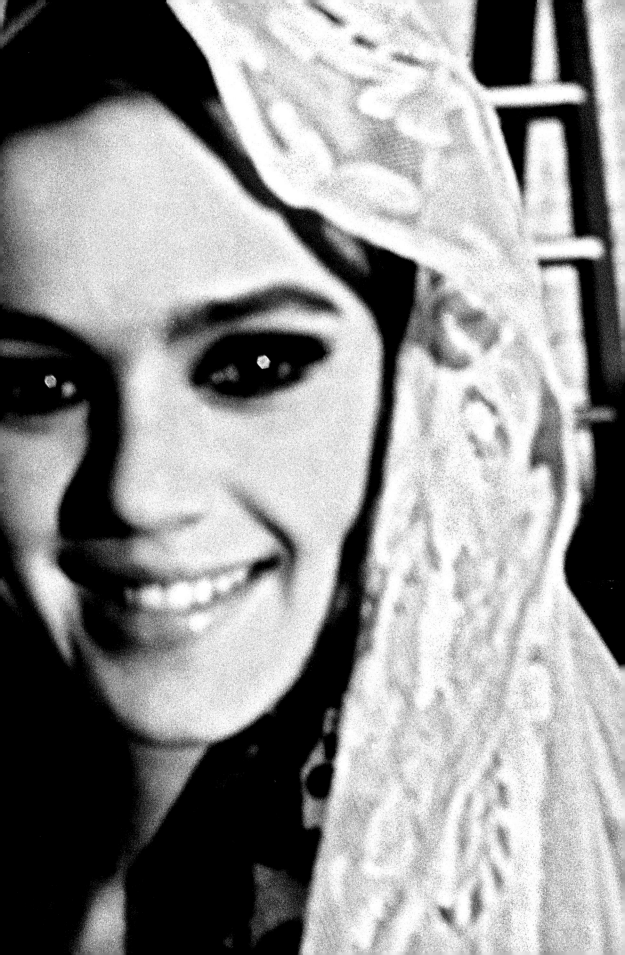

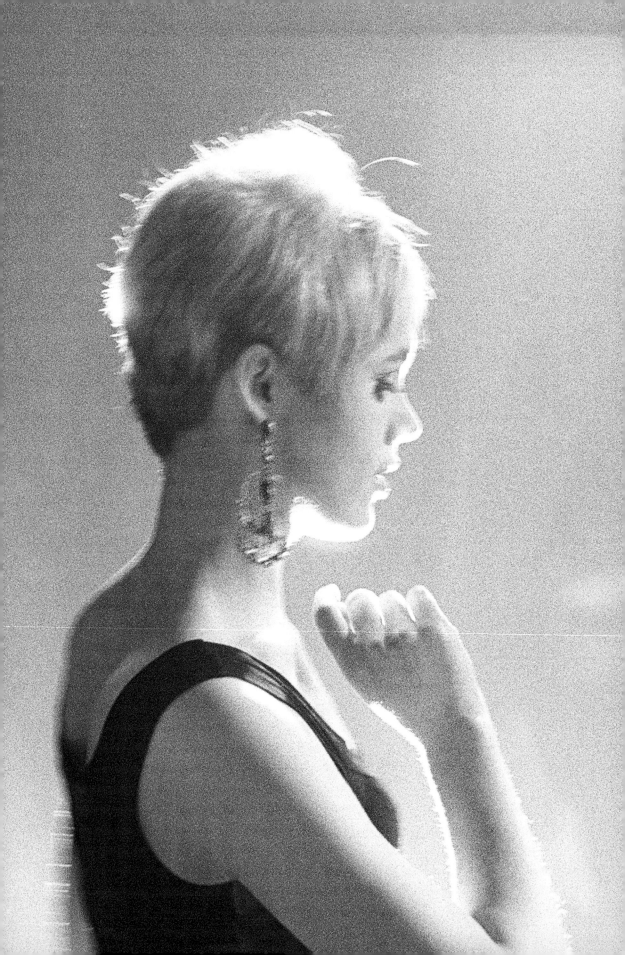

BETSEY JOHNSON (IN *CIAO! MANHATTAN*):
HE KNEW THAT IN EDIE HE HAD FOUND SOMETHING EXCEP-
TIONAL—UNIQUE. EDIE ENCAPSULATED THAT WHOLE ERA
JUST WITH THAT NONCHALANT/INTENTIONAL HOLLY
GOLIGHTLY LOOK: FIVE PAIR OF LASHES, LIP GLOSS, HEAVY
BLACK MAKE-UP, THAT VIDAL SASSOON HAIRCUT. AND EDIE
RAN WITH THE WILD HORSES. I MEAN, EDIE WAS NOT ONLY
THE LOOK, SHE HAD THE HEAD, SHE HAD THE BODY, SHE HAD
THE SCREWED-UP BACKGROUND. I MEAN, SHE'S A PERFECT
CANDIDATE. YOUNG, GORGEOUS, THE LOOK OF THE TIME,
ON ANDY'S ARM, AND ABLE TO REALLY HOLD HER OWN.
FALLING DOWN, STANDING UP, WHATEVER, SHE WAS A ONE
IN A ZILLION. THERE'S NEVER BEEN A PERIOD IN TIME AS . . .
HEAVY! AS STREET-THEATER BREATHTAKING! AND REAL! AND
EDIE WAS JUST THERE WITH IT. SHE WAS IT. I DON'T KNOW
WHAT IT IS, BUT ANDY ALWAYS WANTED TO BE AROUND
PEOPLE WHO LIVED IT, WERE BORN IT, DID IT ALL, DID ANY
THING THEY WANTED TO DO—AND THAT WAS EDIE.

Spinning Girl

Judy Garland and Edie derived much of the attention focused on them from two distinct varieties of camp, a concept that is so common today that it's become a cultural meme, the stuff of sit-coms and commercials but which at that time had only recently been explicated for straight society by Susan Sontag. In Judy's case, the camp effect was unintentional. Her messy life had swamped her original incarnation as the radiant Dorothy in *The Wizard of Oz* and made her into the butt of jokes. Edie's use of camp was playful and sophisticated enough to be tantalizing to the general public, who could only vaguely grasp what was going on.

Edie and Judy had other things in common. Both were damaged children who delighted in high drama and were adept at mounting their own theatrical productions whenever and wherever, casting in these impromptu plays whomever happened to be around them.

ANDY WARHOL (IN *POPISM*): Judy Garland and Edie get people involved in their problems and their problems made them more appealing and you forget your own and help them.

Edie wanted things to conform to the little theater in her head—the world being what it is, that didn't always happen. She was ready to take her imaginary kingdom, the one that had first blossomed at Rancho La Laguna, into the real world. The glamorous freak, "the King's Daughter," the Princess of Pop with her multi-colored pills. The child in full tutu bursting after dinner into her parents' party to perform her ballet dance from *Swan Lake*. Isn't she adorable! A little doll! The little doll who never grew up. That was a huge part of Edie's charm.

Social life revolved around her as it had done in the years before she left home. Wherever she went she was the center of attention, a Copernican system, where she was the charismatic solar deity around whom everything revolved. As long as her charisma magnetized the gravity in the room, it was her movie. She was so charming (and slightly addled) that people granted her the floor. She spun and spun them around her. They participated in her game, which was more fun than the one they were playing: trading stock tips, accounts of their children's progress in college, recent adulteries, and the golf course at Pebble Beach.

Edie had perfected her creature and Andy wanted to preserve it under glass. A few weeks later, Andy asked Ron Tavel to write a script as a star vehicle for Edie. This was *Kitchen*. Despite his infatuation with Hollywood, whenever a scene in one of Warhol's films began to look like a Hollywood movie it always made him nervous. Of course, with Ronnie Tavel as screenwriter he had nothing to fear. Warhol told Tavel to get rid of any residue of plot. This was an old ruse of Modernism, the cuckoo clockwork of the well-made plays of Sardou and Scribe had to be junked. In its place? Circularity, stasis, the ouroboros of *Finnegan's Wake* and *Waiting for Godot*. Wasn't plot just a disease of the bourgeois theater anyway? The vulgar illusionism, the conformity to small-minded morality was insufferable and absurd—but not absurd enough! The ideal was a story that goes nowhere.

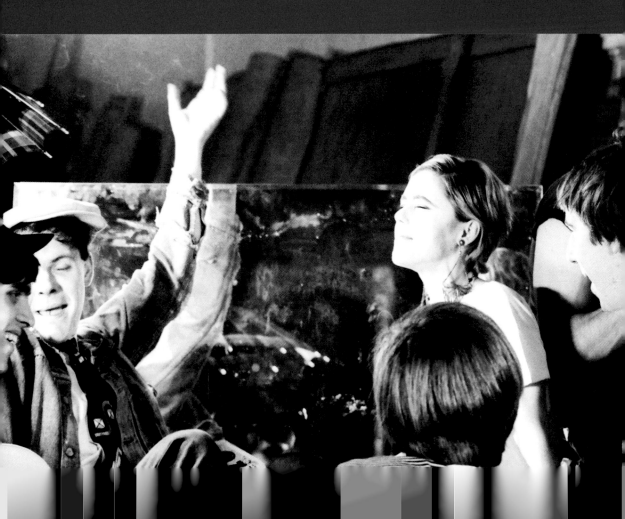

This shift in interest on the part of the public for the odd and idiosyncratic had been preceded by the popularity of foreign films—in other words, art movies. Fellini, Godard, Buñuel, Bergman. Hipster, Beat movies like *Pull My Daisy*. By the mid-'60s the phrase "underground movies" had a sexy twang to it. "The first time I met Warhol," the *London Observer* wrote breathlessly in 1966, "he was busy making a film starring Mario Montez, a Puerto Rican shipping clerk. Dolled up as Lana Turner. Warhol is the leading figure in the 'Underground Movies,' a movement of experimental film makers that's taken Greenwich Village by storm."

Underground movies were trying to jettison the claptrap of Hollywood in much the same way that the theatre of the absurd had tossed out moribund theatrical conventions. Beckett's *Endgame* had unfolded with all its doomed, crippled, and garbage-can dwelling characters stranded as if in an existential waiting room. But now Andy had decided, in his feckless way, to get rid of character, too—which is why in *Kitchen* everybody has the same name.

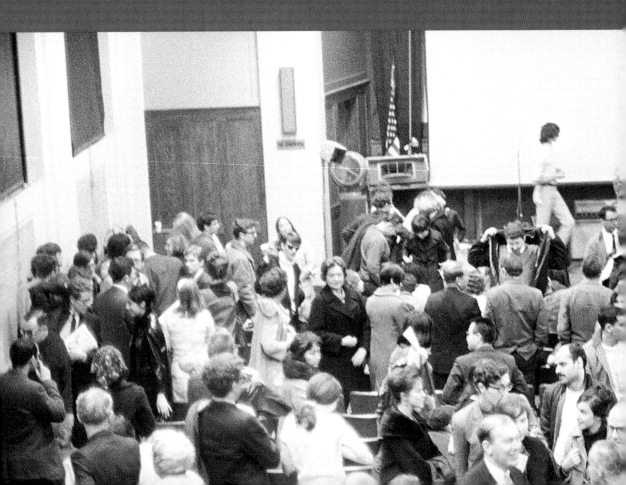

RON TAVEL (PLAYWRIGHT/SCREENWRITER): Andy had in mind a series of all-black and all-white films, and *Kitchen* was Andy's first experiment with the all-white film. Since *Vinyl* had come out all-black, it gave him the idea that an all-white film would be interesting juxtaposed with it. The idea of putting the two side by side would not occur until fourteen months later with *Chelsea Girls*. A pure white screen with a blonde in it and then a black screen with people like Ondine, Gerard, and the leather set people. Andy wanted a situation rather than a plot for *Kitchen* because he wanted it to look presentable to Hollywood people. I naturally wrote it in an absurdist mode; that was the thing of the day. It's the closest of all my works to Ionesco, but there's also a sense of Abbot and Costello, who are one of my favorites. Andy thought it was the best script I'd done to date, but it failed because Andy couldn't make it work either as an absurdist play or as realism—hence the mess that it is. But Andy was very shrewd about this from a publicity point of view. He said, "Good or bad doesn't matter. Extreme bad and extreme good is very good. What's no good is in between."

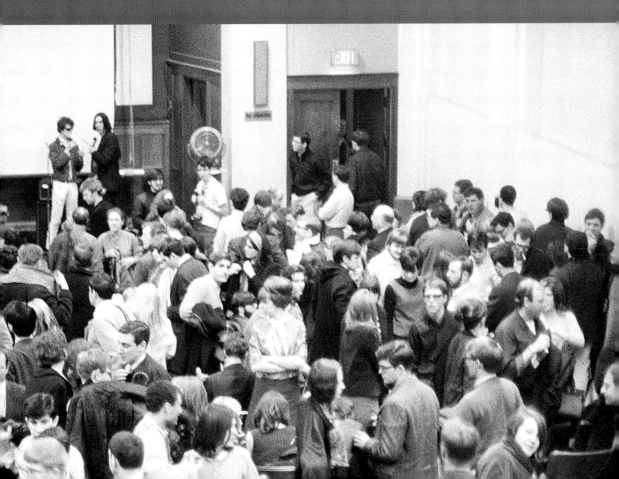

The theme of *Vinyl* had been S&M, which is, by its very nature, theatrical—basically, sexualized melodrama. But the theme of *Kitchen*, if anything, is the opposite: claustrophobia in a bright white space. Almost all of Andy's other Edie movies are solo performances involving Edie making up her face, gossiping on the phone or talking to herself.

Shot in Bud Wirtschafter's kitchen (he was briefly a soundman on early Warhol films), *Kitchen* is a kind of diorama of the Factory condensed into a white cube. It would be difficult to summarize the plot of *Kitchen* (probably because there isn't one), but it could be interpreted as suburban malaise as fantasized by a group of freaks, with Edie (on the set in this photo by David McCabe) as the bored housewife, Roger Trudeau as the beefcake boyfriend/husband, Donald Lyons as the gay neighbor, Electrah as the gum-cracking slut, and René Ricard as an unlikely houseboy—with walk-ons by photographer David McCabe and Gerard Malanga.

In *Kitchen*, Trudeau desultorily tells Edie he's had sex with someone in the shower and proposes they have sex on the beach when it's dark and there's no one around, to which Edie responds, "You know how much sand hurts." When Electrah arrives she rants about what Edie and Trudeau do behind dark doors: "He does dirty things between your legs."

But basically, nothing happens. And it's impossible to tell what's meant to be in the film and what just wandered into it. As a showcase for Edie, though, it's perfect. There's nothing to distract you from Edie in striped shirt and tights—not plot, not dialogue, not even common sense. As a rule there were no rehearsals for Warhol movies, but clearly, for Warhol, *Kitchen* was something different, the film that would launch Edie. "We're going to make her our Superstar," Andy told Tavel. "She will be the queen of the Factory." So this is one of the few Warhol films that was rehearsed. Not that it did much good. Edie had a hard time remembering her lines. Pages of script were secreted in cabinets, in the refrigerator, in drawers, on chairs, hidden in books. Despite all these aids, Edie skipped whole passages, turned back to earlier in the script, lost her place again—all of which brought on sneezing attacks. If she forgot her lines she was told to sneeze and someone offstage would whisper them to her. There is a lot of Edie sneezing throughout the film.

Words and phrases, like "litter basket" are tossed around like found objects or random entries from a foreign language phrase book. But Edie found this absence of motivation unnerving and kept asking Tavel, "What does this mean?" Tavel's point was that lack of meaning was the point—he was trying to say nothing, one of his models being the genius of tautological poetics, Gertrude Stein.

Why We're in Vietnam

When Edie becomes annoyed with other people's conversations or questions in the film, she turns on the malted machine to drown out words completely.

BILLY NAME: This was the first fall out with Edie. Because she wouldn't do the lines Tavel wrote. She couldn't understand what it was about—and since it was deliberately absurdist dialogue there was no way to make sense of it. There was no coherence to the scenes and Edie couldn't work like that. She didn't want to memorize these non-sense scripts. Ron had been a playwright before writing scripts for Andy; he was an absurdist writer like Paul [Morrissey]. Ronny was very high class, avant-garde, uppity. Beyond existential, one of the first post-modern minds.

Kitchen is so unmoored you can make anything you want out of it—which is in a way part of its genius. To some it might be simply camp absurdism. To Norman Mailer, it marked the beginning of the end:

NORMAN MAILER (IN *EDIE*): I suspect that a hundred years from now people will look at *Kitchen* and say, "Yes, that is the way it was in the late fifties, early sixties in America. That's why they had the war in Vietnam. That's why the rivers were getting polluted. That's why there was typological glut. That's why the horror came down. That's why the plague was on its way." *Kitchen* shows that better than any other work of that time.

Talk about left-handed compliments. Bits of camp existentialism are thrown in like pastiches of Sartre, of Camus. When Edie offers a piece of layer cake to Donald Lyons he says, "That's the story of my life too, one meaningless layer after another." At this, Edie begins to cry. "That's just it," she says, "I don't have a layer of my own."

Kitchen's very inaccessibility and obscurity is part of its attraction. Along with *Chelsea Girls*, it represents the high point of Warhol films before they morphed into gaysoftporn art movies like *I Am a Man* and *Bike Boy*.

Late morning, early afternoon

Edie consulting the *I Ching*, as she did every morning. Tiny prognosticating T'ang goblins rise up from the page and announce the News of Things to Come. Then there's the almost Kabuki-like dedication to her maquillage, hours upon hours, painting and repainting her self-portrait. Spidery lashes, white lips, gold dust eyelashes.

DANNY FIELDS: In the spring of '64, Edie, Tommy Goodwin and I and two other guys went to the World's Fair. We got there and there was a ladies room at the bottom of the staircase and Edie said, "Oh, I've got to run in." She meant she had to do her make-up. Three and a half hours went by, maybe it was four hours, and she's still in there. We just sat there outside the ladies room. We didn't know what to do, but we knew very well what she was doing. Her make-up was probably the most important thing in her life.

Then—and during the manic maquillage ceremony—Edie's on the phone … on the phone … on the phone…. in that low husky voice "as if she'd been crying." Choosing outfits. What will it be? The white mink coat over striped shirt and tights? Bangle bracelets, high heels, sleeves pulled up, giant earrings that echoed her lunar eyes, dime store t-shirt? Thigh-high boots, micro-mini skirt, chubby fur jacket, Kenneth Jay Lane earrings—or the Robert Indiana LOVE earrings? Anoushka Beckwith, an 18-year-old fan, evokes Edie's playful rummaging:

ANOUSHKA BECKWITH: It's like when you're a five-year-old and you go in your mother's closet and sit down in front of the mirror and put on loads of make-up and her big jewels and then her furs and then her shoes and wander around. But the way Edie did it wasn't goofy or funny. Somehow it was always very chic and intentional.

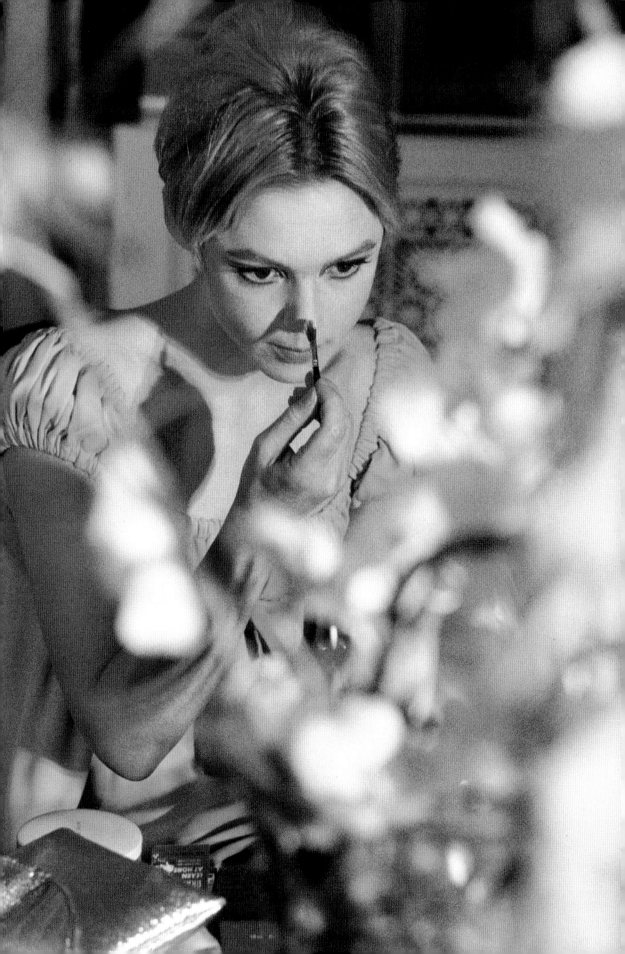

All the while that Andy and Edie went on making movies at a frantic rate—eleven movies in four months—Edie also pursued her social life with missionary zeal. She traveled in a bubble, always by limo, insulated from the world (even taxis were too real). As for public transportation, she didn't know what that was.

DANNY FIELDS: The famous transit strike was going on and everything was shut down. Someone said, "Oh well, it's too bad we can't go to that party because of the transit strike." And Edie said, "A transit strike? Oh that sounds so glamorous; what does it mean?" "There are no subways," we told her. "I have an idea," she said. "Let's take a bus! I've never taken one; now I can find out what a bus is like." She didn't understand basic things like that; they were beyond her ken.

When the paperback of *Edie* came out, Andy said to Pat Hackett, "Edie's on the sides of buses. The ads for the paperback. Poor Edie—when she went out she'd never even take a cab, it had to be a limo, and now they've got her on the bus." (*Andy Warhol Diaries*, Sunday, May 1, 1983.)

Late lunch at L'Aventura. Her favorite restaurant (near Bloomingdale's) is host to lunch for eight or twelve people, with Edie picking up the tab. Then mad shopping expeditions, charging mountains of clothes, jewelry, ransacking cosmetics departments like a Mongol horde. An astounding amount of clothes—often buying the same outfit twice—sometimes deliberately (you can't have too many mini-skirts), sometimes because she'd forgotten she already had it. And more shoes than Emelda Marcos.

DANNY FIELDS: She'd take the bills out of a big envelope and put them into piles depending on which drug store they came from: Cambridge Chemists, Madison Pharmacy, or you know Lennox Hill, whatever. And they'd all be in the neighborhood of $600 to $900 a month. She would go in and they'd say, "Oh, Miss Sedgwick, the new Helena Rubinstein lipstick line just came out." It would be called Daughter of Pearls or something. And she'd say, "Ohhh, let me see the colors." And then she'd just stare at these 20 new things, but she didn't want to have to make up her mind and so she'd buy them all. Very lovable and very spoiled.

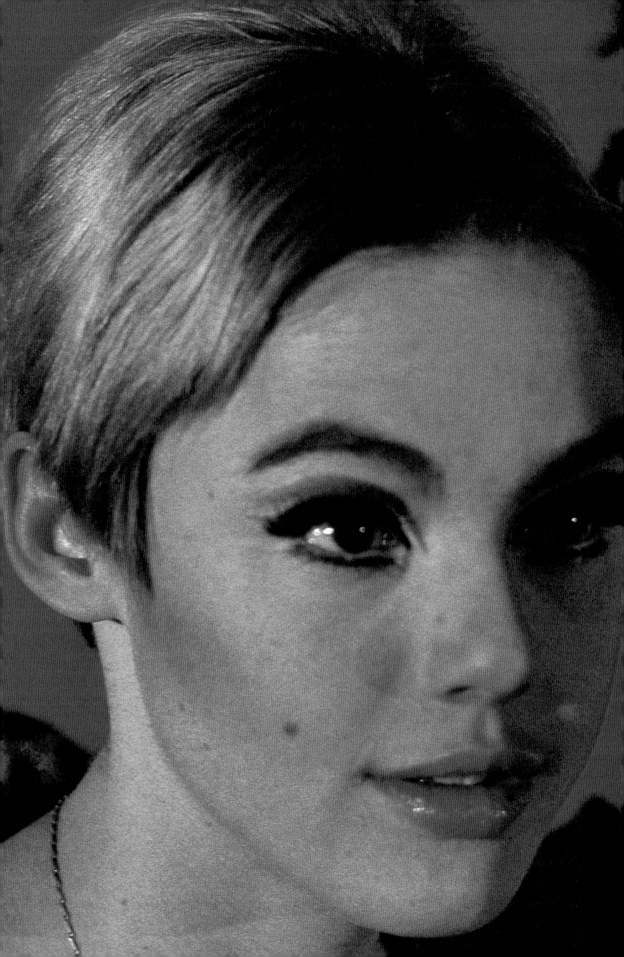

ILEANA SONNABEND GIVES WARHOL A S
IF HE CAN TAKE HIS ENTOURAGE. SONNA
MORE TICKETS. IF HE COMES WITH A PR
GET MORE PRESS, SHE TELLS HIM. AT C
THE HAT-CHECK GIRL ASKS EDIE IF SHE'D
"IT'S ALL I'VE GOT ON." EDIE'S LUGGAGE
MINK COAT. IN PARIS, ANDY ANNOUNCES
HENCEFORTH DEVOTE HIS LIFE TO MAKIN
FILMS ARE EASY." ANDY KNEW HE WAS
THE THREE-YEARS-OF-FAME RULE APPLI

V IN PARIS AT HER GALLERY. ANDY ASKS
D IS ONLY TOO HAPPY TO SEND HIM
Y UNDERDRESSED GIRL HE'S BOUND TO
EL'S, A FANCY PARISIAN RESTAURANT,
E TO CHECK HER COAT. "NO," SHE SAYS,
TAINS NOTHING BUT ANOTHER WHITE
S RETIRING FROM PAINTING AND WILL
LMS. "PAINTINGS DON'T GO FAR ENOUGH.
A CROSSROADS. HE UNDERSTOOD THAT
O HIM, TOO.

Poor Little Rich Girl

Andy's early movies with Edie are essentially extensions of the famous Warhol screen tests, which are at the center of his idea of film. "I only wanted to find great people," he said in *POPism*, "and let them be themselves and talk about what they used to talk about and I'd film them for a certain length of time and that would be the movie." The screen tests are the most stringent example of this philosophy, and haunting because of the psychological leakage that happens when a subject is scrutinized in silence over time.

The origin of these mesmerizing mini movies was Warhol's ill-at-easeness with visitors to the Factory. A famous person arrives, or, say, an interesting or too curious visitor. Andy's solution is to plonk them in a chair and turn on the camera as it scans the sitter's face and body movements with laser-like penetration. It was always desirable to put some piece of equipment between himself and other people; it kept people at a distance.

APRIL 1965

Poor Little Rich Girl is a distillation of this idea, in other words a beautiful, unwatchable film. Edie talking on the phone, walking about her apartment, going on about being a debutante who'd just spent her entire inheritance in a matter of months. This is Andy's first full-length portrait of Edie.

ANDY WARHOL (IN *POPISM*): I always wanted to make a movie of a whole day in Edie's life. But then, that was what I wanted to do with most people. I never liked the idea of picking out certain scenes and pieces of time and putting them together, because then it ends up being different from what really happened—it's just not like life, it seems so corny.

And Andy pursued this relentlessly through the spring and into the summer of 1965. *Face*, with Edie, was also shot in April; *Restaurant* (Edie at L'Aventura with Ondine and Bibbe Hansen) was filmed in May; *Afternoon* was filmed in June; and the *Beauty* series about Edie and her boyfriends was shot in June and July.

All of these portraits of Edie are cinema verité of a very literal, deliberate, mind-numbing variety. Andy didn't believe in editing (even if it was sometimes needed to make the film look as if it hadn't been edited). And no rehearsing. Why would you need to rehearse to be yourself?

ANDY WARHOL (IN *POPISM*): To play the poor little rich girl in the movie, Edie didn't need a script—if she'd needed a script, she wouldn't have been right for the part.

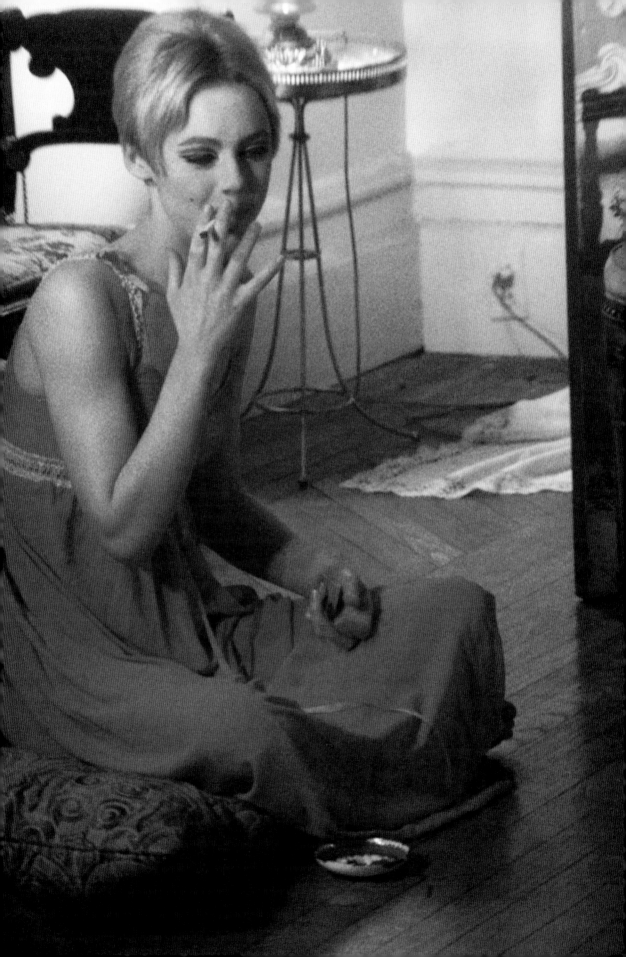

Doctor Meth

Late afternoon. On to Dr. Robert's office on East 48th Street for a poke. Dr. Roberts, Dr. Feelgood to the stars, a drug shaman who imbibed his own potions, launching into epic raps that branched off into lush digressions that in turn grew kudzu tendrils. The satellite dishes planned for the roof (to catch alien whispers from space), and a heliport so his patients could get their shots and take off for the Hamptons, Washington, Xanadu. A speedfreak's delusional plans for neocortical architecture, sonic vibrational mood rooms, rooms that breathed, rooms that rotated, black-light rooms, a scale model of the Ganges in the basement.

Meanwhile, the office itself was never finished, the waiting room filled with desperate types. Vampirish ghouls awaiting the drink of incandescent blood that will revive them, that one last shot to get it all right again. The pixie lust dust crowd: Queen Bee Speedfreaks, Amphetamine Annies, and extra-planetary Crank Crunchers with kleptomaniac habits, all rifling through Edie's apartment (left open as she dashed out on some urgent quest). Edie was pretty light-fingered herself—anything she thought was rightfully hers and wasted on them: leopard-skin coats, hats, jewelry, tchotchkes, drugs. Occasionally, she'd leave a meaningless I.O.U. for the object she'd just appropriated. She never left an apartment without a memento. A kleptomaniac who gave everything away, as a friend said of her.

Edie was also a mad devotee of speed, "the sacrament," just to "keep that superlative high, just on the cusp of each day . . . so that I radiate sunshine." It pulled the picture into cubistic 4-D focus, the scene into brilliant Technicolor; it made you more yourself than you could ever be—Edie to the tenth power! It was the super-natural, intravenous religion. After a speedball (a shot of heroin and cocaine), Edie reverted to ecstatic infancy and ran out onto Park Avenue "naked as a lima bean," as she put it.

ROBERT HEIDE: I would run around town with Edie to different places shopping and then to the Ginger Man. We'd stop off and have vodka Bloody Marys and stuff. She'd just talk about nothing really—these far-fetched projections. I don't know if you've ever been around models, but they just fantasize about these truly implausible things, you know— they think of themselves as these kind of hundred million dollar hookers, and it's all just, shining, shining.

She also knew the speed horrors, which she describes with ferocious precision in the *Ciao! Manhattan* tapes: "The nearly incommunicable torments of speed, buzzerama, that acrylic high, horrorous, yodeling, repetitious echoes of an infinity so brutally harrowing that words cannot capture the devastation nor the tone of such a vicious nightmare." Like many drug users, she saw amphetamine as a form of self medication, ultimately believing only a drastic form of homeopathic blitzkrieg could save her: "I just kept thinking if I could pop enough speed I'd knock the daylights out of my system and none of the nonsense would go on."

All that grim doubting business came later; for now, speed was miraculous. She was traveling at a velocity at which time stops, fusing pastpresentfuture into the zinging now.

BIBBE HANSEN: She was taken out of being a functional, operational human being long before she passed. If the drugs hadn't been there, who knows what might have developed, and generally people who are that non-functioning and use that many drugs, they don't develop. That is the tragedy. So we get to see how much, in spite of all the shots against her, in spite of the damage done in her early years, and despite the drugs, she did achieve. The drugs weren't a sign of indulgence, they were medication, babe—she was, like, majorly medicating herself with some very serious stuff.

70 Minutes of Foreplay

Beauty #2. A beautiful skinny young girl (Edie) in black bra and panties, pale skin, dark eyes and a handsome swarthy young man (Gino Piserchio) engage in mild sexual play while Edie talks and answers a barrage of questions from an off-camera interrogator. A bed in a hotel room in eternity. No exit. Drugs, booze, cigarettes, maybe a TV set out of view. *Beauty #2* is a tableau vivant in which the actors, sanctioned by Andy's black wand, with somnambulistic fervor indulge in foreplay without qualm—not that Edie and Gino needed any encouragement in this direction. As Edie says coquettishly at the beginning of the movie, "I say good friends should lie together."

The camera, the glass and metal eye that potentiates the voyeur's arousal, prodding the lovers' bodies like a finger probing, caressing with ghostly touch the objects of its curiosity. The scene goes on for 70 minutes. The two lovers can barely stay awake as they drift in and out of mild narcoleptic sexplay—all egged on by a shadowy grand inquisitor, Chuck Wein, who from the sidelines (we see only his shoulder and head) asks questions, provokes, ridicules and incites the lovers to further exhibitionistic acts. But nothing really happens. Chuck is clearly a stand-in for Andy, the master agent provocateur, but Chuck has his own agenda. Edie, for the most part, maintains her poise and a disarming narcissism, just giggling and deflecting Wein's increasingly irritating attacks. Eventually the relentless harassment gets to her and she breaks a glass ashtray. At one point she asks exasperatedly, "What have I gotten into?" to which Chuck answers, "Nothing but a bra and panties."

The film ends with Chuck giving a description of Edie's depressing routine: "I hope the next 35 minutes will be fun, then you can get tired and I can give you the bottle of pills. You can take the three pills, then Gino and I can leave. I can wake you up tomorrow and we'll find a new doctor."

BILLY NAME: Chuck had great insight but he would do such horrible things. He almost destroyed Edie. She was a semi-polished uncut diamond, and he cut her the wrong way. Even if you see one of the movies and she's off-screen, he's constantly challenging her. And it became so tedious to her that it wore her out. He was trying to make her prove something. He was trying to make her into a witty, more clever person, always capable of taking on any challenge. And it was unnecessary because her poise, her very presence was so wonderful. A lot of it has to do with amphetamines at the time. People would become so zealous about who they were. Chuck would become ten-times-Chuck, super Chuck!

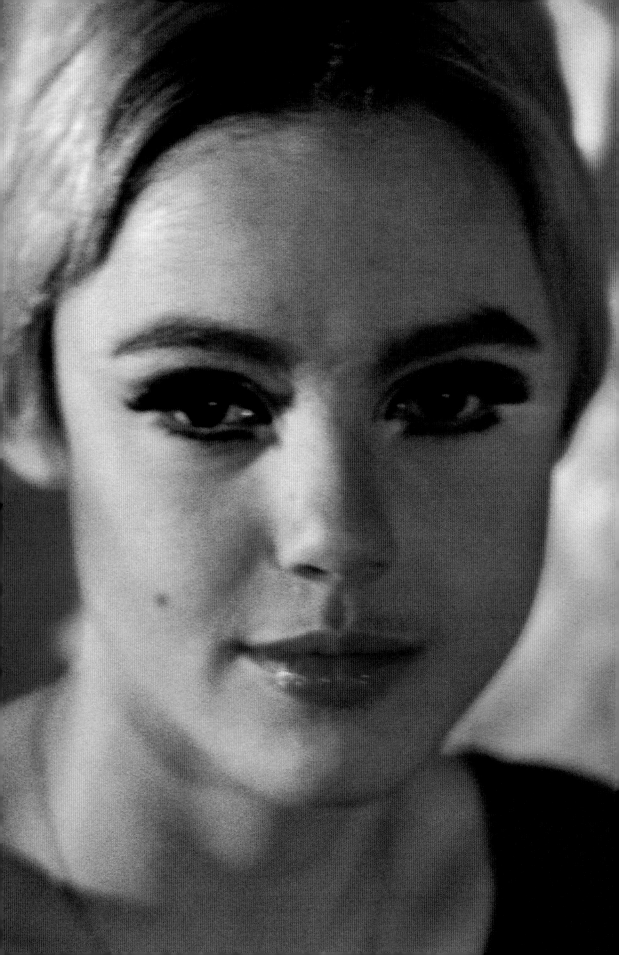

Our Lady of Late

Late late afternoon. Edie's on to the Factory. More insane maquillage. People hyperventilating. What can possibly take that long?

BIBBE HANSEN: She would drive us insane sitting there, you know, on more than one occasion with her make-up case, sitting there, just endlessly, endlessly, doing her make-up while everybody was, like, starving and late for the party and late for this and wanting to go and everybody becoming so irate. But look at the celebrities of today, at the army of people putting them together for these events. They have make-up, they have botox, they have Pilates, they have a special guy for eyebrows, they get everything waxed, they have people bringing in clothes and people bringing in jewelry, and the whole thing. Edie did all that by herself. And, yeah, it took a couple hours, but when she was done, she looked fabulous.

By the time Edie appears at cocktail parties, dinners, events, she is astoundingly late. The arrival of La Sedgwick was so frantically awaited that the very air pulsed with anticipation. Her timing was infuriating and immaculate, stretching the moment taut to the breaking point. And just at that point Edie would appear to cries of "It's Edie! It's Andy! It's Edie and Andy!"

ROBERT HEIDE: There was a particular night I remember, a party for *Outer and Inner Space* on the abandoned New York Central Railroad tracks under the Waldorf Astoria where they had these old trains. It was a really super party. Diana Vreeland was there and just everybody in town. All these fancy dressed-up people screaming and dodging rats and cockroaches. Andy and Edie were supposed to show up at a certain hour for the movie to begin and it got later and later and still there was no sign of them. The anticipation was palpable. Then finally they both emerged out of this train and she was in the little t-shirt, the stockings, the earrings and her hair the exact silver of Andy's wig.

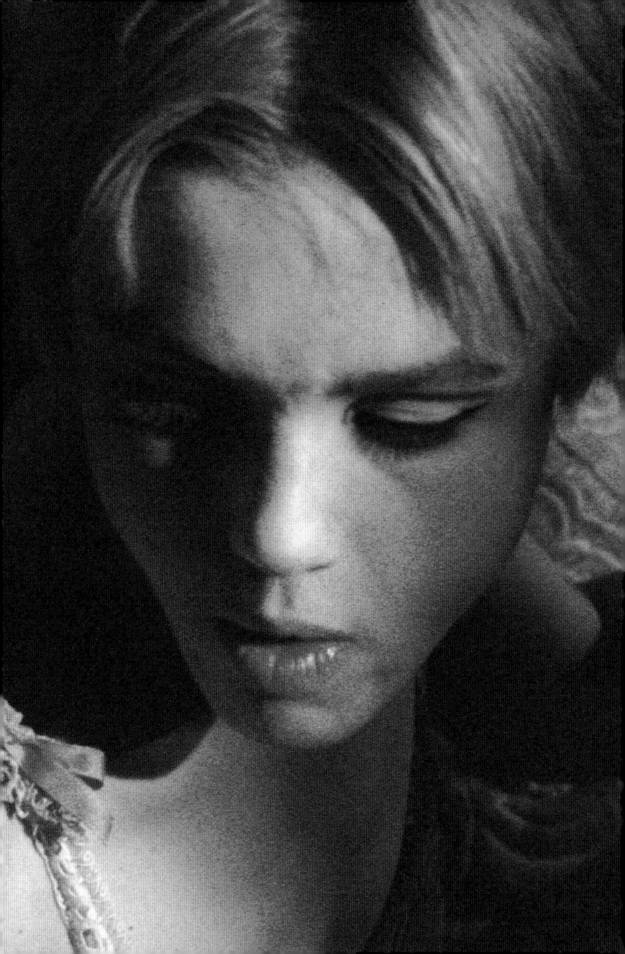

THIS PARTY, T
NEXT PARTY ...
BECAME A PE
AND OF ITSEL

Four Faces

In July of 1965, Norelco loaned a prototype of the first home video camera to Warhol for promotional purposes. According to Andy they'd given him the video camera in order to get his rich friends to buy one. It was on this machine that Andy made *Outer and Inner Space*, his most sublime and moving portrait of Edie. An existential Ophelia high on Desoxin, you can see the wheels of her mind spinning in cycles and epicycles. Edie—lips glossed, wearing a pair of giant dangling earrings, her eyes sparkling—is seen seated on a stool next to a television monitor on which her image is displayed. Andy had previously videotaped Edie talking about space, the supernatural, gossip, the past. Then, using a monitor showing the first video as a source of illumination, he reshot Edie next to her videotaped image.

Alternately composed and animated, melancholy and reflective, Edie talks on and on, occasionally puffing on a cigarette. From time to time she seems to become disturbed by the sound of her own voice on the monitor, like an intruding conscience whispering into her ear. "It makes me nervous to listen to it," she says. Her attention is fragmented by this double of herself, as if the two Edies were a manifestation of her schizoid personality. The sound quality is terrible, so it's difficult to make out what her overlapped monologues are about. You catch the occasional, wistful phrase: "We had better times than anybody else," or "I don't believe it." But it doesn't matter what the exact words are, it's Edie meditating on her past, memories and scenes leaking information from the inner chambers of her mind. Reviewing *Outer and Inner Space* for the *New York Times* in 1998, J. Hoberman said of Edie's distracted, ethereal manner, "She acts as though it's tea time on Mars."

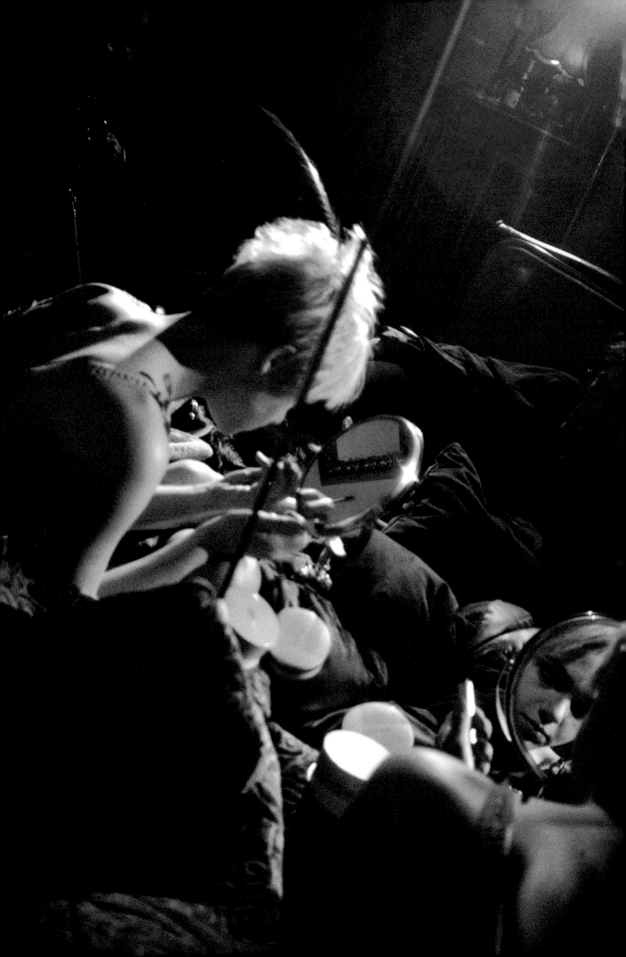

Nightworld

After hours. On to Max's Kansas City. As soon as it opened in the fall of '65, Edie became the Queen of the Scene. The backroom at Max's was her court, where dedicated followers of fashion came to offer their allegiance. After Max's closed there were the funny little Mafiosa bars in Little Italy or the bronzy catacombs of the Brasserie in the basement of the Seagram Building. And in the early morning, there was the Fulton Fish Market, where the bar was open all night and you could buy clams and oysters for your hangover.

The nervous chauffeur directed down to the lower depths, engine idling, smoking a cigarette—an errand into Hell—his elfin charge disappearing through a battered metal door, yellow stripe directing zombies to the shooting gallery round the corner, transvestite hookers, the meat packing district. He fantasizes the ghoulish front page of the *Post*: "DEBUTANTE'S BODY FOUND IN DUMPSTER" "WARHOL STAR IN DRUG SLAY." Her companions, dubious at best, high on god knows what—freaks, circus people with too much money and no sense.

And so, to bed. But even in sleep, Edie never stopped moving. Her hands were wide awake. The autonomic nervous system kept ticking, her hands waved and clawed and scratched. They had lives of their own. Restless body syndrome. Queen Akathesia.

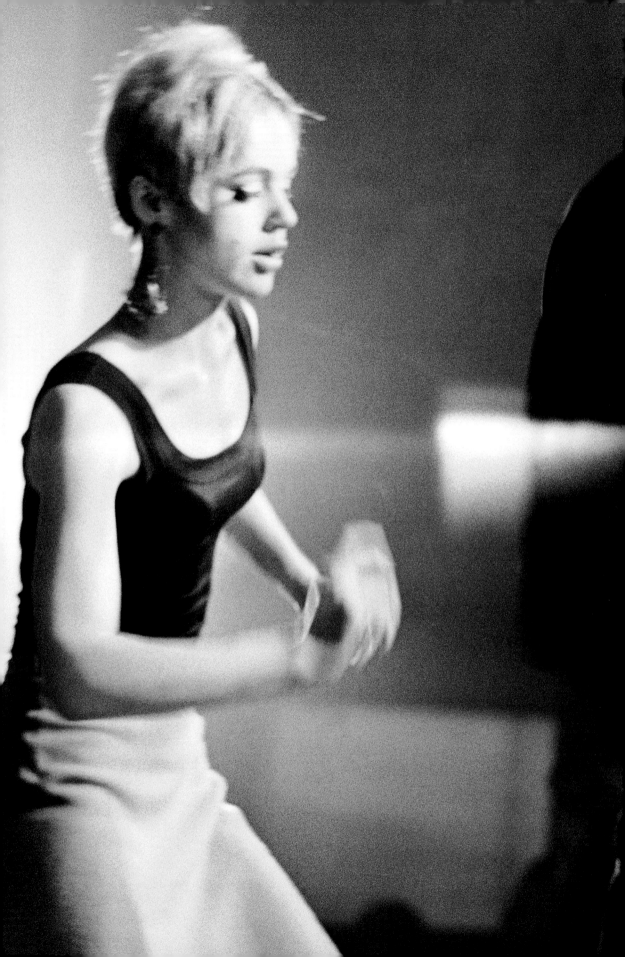

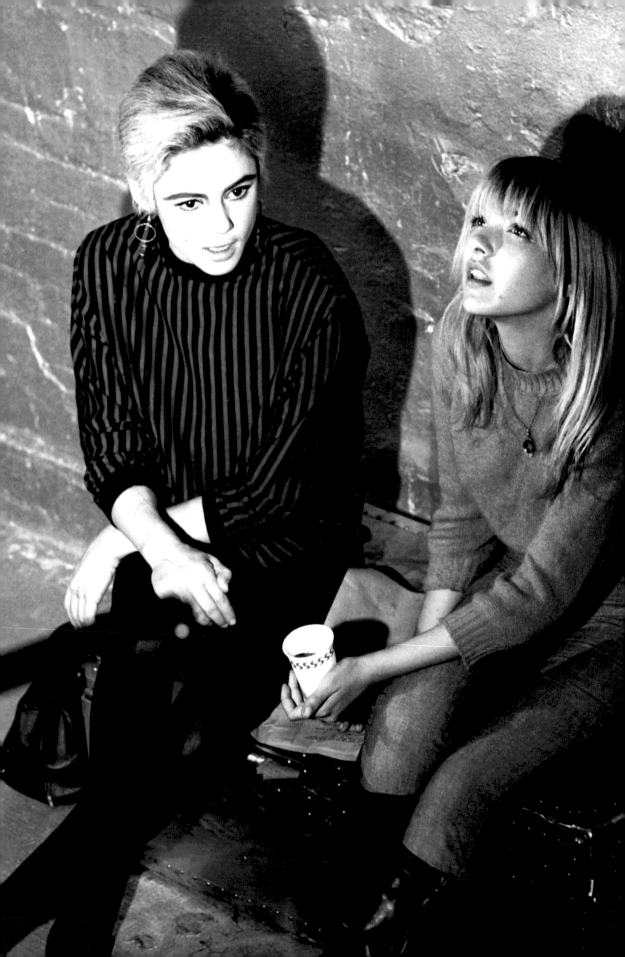

Behind Bars

Prison, shot in July, has what almost amounts to an actual plot, or, at least, a titillating situation.

BIBBE HANSEN [PICTURED AT LEFT]: I was a bit of a wild child. In those days, if you didn't go to school, they would come and lock you up. I wound up, as we used to say very politely, as a "guest of the City." I was in a Bronx youth house called Spofford, which was a pretty serious lock-up child prison. Tony Curtis was an alumnus. I had been there a couple of months and my father [Al Hansen] sprang me on a Friday and on that Saturday we did the thing of doing the galleries, and then you'd end up at this coffee shop on the corner called Stark's. We walked in and there was a whole group of guys sitting in one corner—Andy and Chuck Wein and Gerard Malanga, also Roy Lichtenstein, and maybe Dick Bellamy and Jim Dine—and they invited us to join them. Al was always broke, so when somebody invited us to eat... boy, you'd never have to ask my Dad twice! At one point, Andy just sort of like, zeroed in on me and said, "What do you do?" And my father said very proudly, "I just sprang her from jail!" And Andy said, "Well, oh my! Tell us all about THAT!" So immediately I was in charge of the theater; I was quite "on," and I gave Andy a couple of short anecdotes. I told him how every time you wanted to go somewhere, you had to go through giant locked doors and the matron with a big key would come lock it behind you. And how you had to line up by size and each girl had to have her toes inside a separate linoleum tile box directly in line behind the girl in front of her, and female monitors would go up and down the line and say, "Box it off, bitches!" Andy was just entranced, and he and Chuck Wein, both blurted out at the same time, "We have to make a movie of this! Will you come to the Factory and make a movie?"

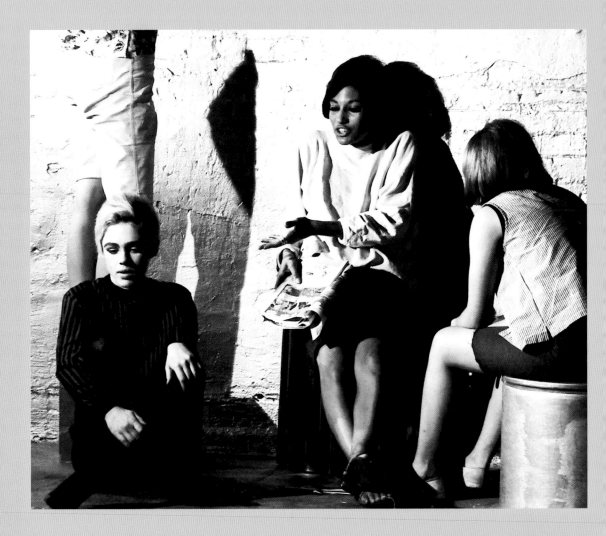

Initially Baby Jane Holzer had been cast in the role of a socialite who'd gotten locked up for knocking over a trash can or something like that, and wound up in the youth house with somebody who was coming back for the third time. "That was me," says Bibbe. "A very seasoned veteran." The film was the confrontation between these two girls—the wild street kid (Bibbe) and the society girl at the prison intake, with Marie Mencken playing the sadistic matron.

BIBBE HANSEN: I told them about the infamous three questions: "What are you in for?" "Are you a virgin?" "Do you go with girls?" The typical questions everyone has to answer. They weren't going to tell Baby Jane about them because they were planning on doing something they called a "real reel," in other words a situation that would lead to psychodrama. Jane Holzer must have known something was up; she had been in a movie or two already and was a bit concerned about Andy's films having a negative impact on her relationship with her family. Andy was somewhat scandalous in his movies, so Jane said, "No, no, no, I'm not making any more movies with you, thank you. That wouldn't be a good idea for me right now." And Chuck said, "I know. Let's get Edie to do it!" Andy said, "Yeah, cool!" So it was decided that Edie would play the part of the socialite. I knew what we were doing with the Youth House stuff, so I took the lead and Edie reacted to that. Edie's whole thing was just to play herself in these situations, which is something that happens in Hollywood movies—but Andy made it sort of a principle: all you have to do is to present this incredible person and that's enough. Except in Andy's movies it was just a still camera. It didn't move; you had to walk in front of it. It was easy for me to relate to Edie—she was very open and friendly. In my own case it was almost like a resonance wave because my mother was so similar to Edie. My mother was one of those people in the late '40s among the Beats in the Village who shone. She had bright green hair, green eyelashes, green eye shadow, green spike heels, green stockings, a raincoat—and underneath it all a green g-string and green pasties. She walked into this cafeteria dressed like that, followed by a couple of dykes balancing make-up cases and costumes on hangers, and my dad took one look at her and said, "I'm going to marry that bitch!"

Freak Debutante

NOVEMBER 21 1965

Andy has his first American museum retrospective at the Institute of Contemporary Art in Philadelphia. Edie in a pink Rudi Gernreich floor-length Lurex gown, Andy dressed in black with wrap-around glasses. Their entourage includes Baby Jane Holzer, Kenny Lane, Isabel Eberstadt, Taylor Mead, and Gerard Malanga.

Sam Green, the Institute's director, has taken out all the paintings before the opening because he fears that they might be destroyed in the crush, and, in any case, as he pointed out, "Nobody comes to art openings to see art anyway." The place is packed with college students; Andy and Edie are mobbed.

A little over six months into their bizarre alliance, Edie and Andy have achieved movie star status. The crowd forces them up a staircase with no outlet—trapped by a predatory mob! Andy has a terror of crowds; to him they were a lynch mob. The villagers with torches were after him. Kill the freak! Andy was Frankenstein, Dracula—his nickname was Drella, Dracula meets Cinderella. The fanatic crowd chants "EdieandAndy! EdieandAndy! EdieandAndy!" A devout believer in retribution, Andy is shaking in his silver socks. It's Sebastian being torn apart by street urchins in *Suddenly Last Summer*.

Edie, on the other hand, exults in the tumult. She's ecstatic. She carries with her the manic, anarchic joy of childhood with its disregard for putting on the breaks. Edie grabs the microphone and charms the crowd, playing with them, dangling her Lurex sleeves, the stretchy fabric getting longer and longer. A Pop Evita. Princess Edie and her devoted subjects ummm-ummm-ummming, the horde blending into themselves in collective worship.

Workers have to break through the ceiling with crowbars and pull Andy and Edie up to the roof. They flee down the building's fire escape.

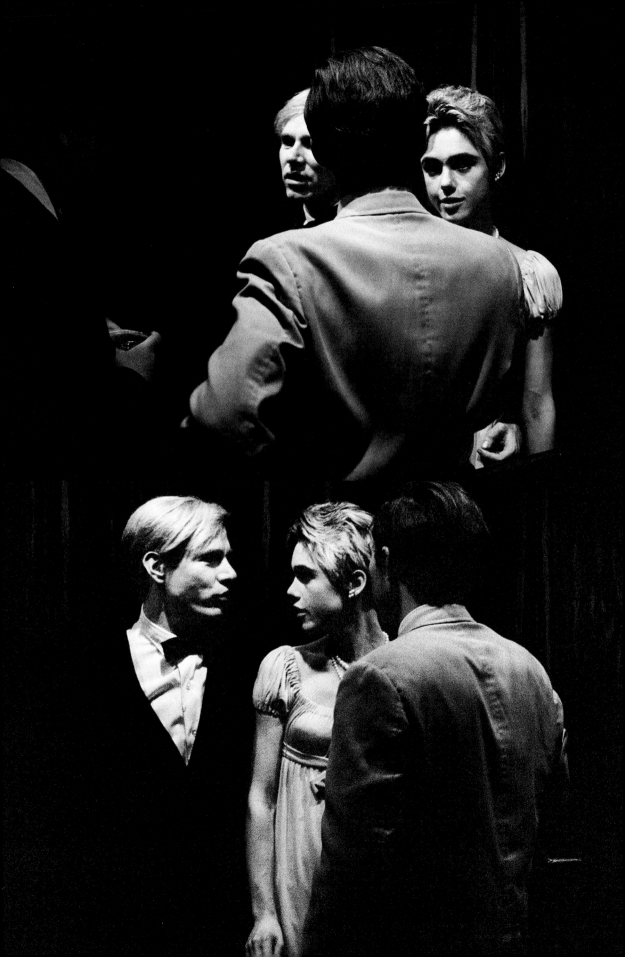

Andy v. Fuzzy

NOVEMBER 22 1965

Fuzzy meets Andy at the River Club in Manhattan, the night of the Cassius Clay/Floyd Patterson fight. Fuzzy is bristling with animus against the freak who has kidnapped his daughter. Warhol's fame is equally galling to Fuzzy. Warhol is a creep famous for his trashy soup cans, while Fuzzy's heroic cowpoke monuments are ignored by the critical elite.

Fuzzy is a Remington rough rider come to life, an acolyte of tradition, prisoner of a mythic past, while Andy, a sort of over-exposed print of Fuzzy, pushes into the future. Two charged particles, matter and anti-matter, but no explosion because Andy does his shrinking act—like a hermit crab folding up inside himself so Big Daddy Sedgwick can't get at him. "Why, the guy's a screaming fag!" is Fuzzy's judgment. But in truth, Andy and Fuzzy are eerily similar, Siamese twins, in many ways: control freak artists, phantom father/lover figures, and, when abandoned, rancorous Trilbys, vengeful Pygmalions.

Sanctuary

BILLY NAME: Those were odd days. Everything is so ethereal and up in the air. It's almost as though everybody's an orchid and you're living in a world of architects.

Never mind that the Factory wasn't ever as cool as it looks in photographs—and far grungier. The tin foil was peeling off the columns, the silver paint flaking off the wall and collecting in little piles in the corners. Any odd ratty thing found on the street was hauled up in the elevator: shopping carts, mannequins, broken chairs. The setting suggests an underground bomb shelter, or maybe the brothel in Genet's *The Balcony*. Word has it the universe is nearing its end, but inside the amniotic walls of the Factory, the revels continue.

To pass the time they dance, gossip, talk on the phone, and perform in absurdist dramas, which only serve to reenact their alienated situation.

BILLY NAME: The Factory was like Grand Central Station. In these pictures it still looks like a painter's studio. I was the deejay whenever there was dancing. We'd do Motown stuff, otherwise it was opera! Chuck and Edie dancing in the front of the Factory. I would have music playing. White trash doing the frug. Everybody dancing by themselves— that was a new thing.

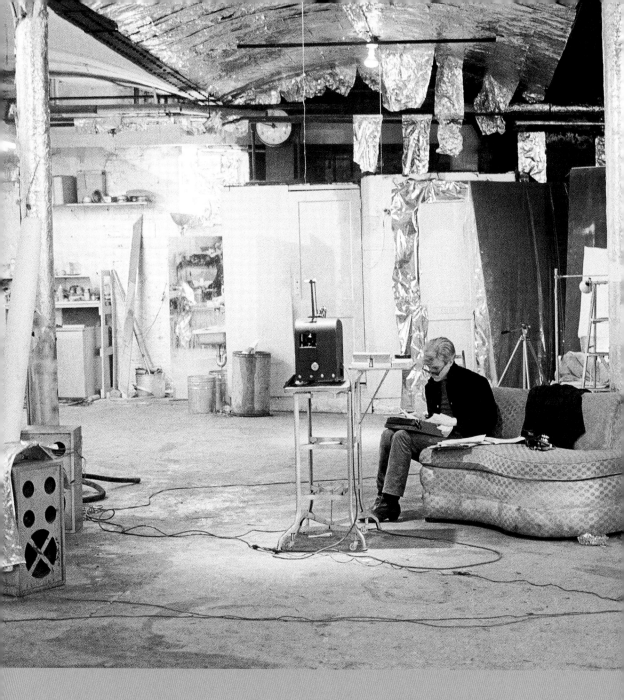

Watching Edie move with stroboscopic motion was fascinating, not just because she was a pretty, stoned girl dancing, but because of a kind of flickering effect, as if something inside her were being switched on and off very rapidly. Andy intuitively recognized this new and unstable element in Edie and the mesmerizing effect it had on people. Smoking, dancing, or reciting meaningless dialogue, she had the uncanny ability to telegraph images of troubled psychological states under a bright, buoyant surface.

The Factory attracted lost boys and confused girls desperately seeking salvation. Andy sanctioned their darkest impulses, not because he was a sinister corrupter of youth, but because, in Nat Finkelstein's apt phrase, "he gave people permission to fuck up."

HER IMAGE—AN

ON THE NEW YO

INDELIBLE THAT

HALLOWEEN PA

ITS UBIQUITY
RK SCENE—SO
PEOPLE ATTEND
TIES AS EDIE.

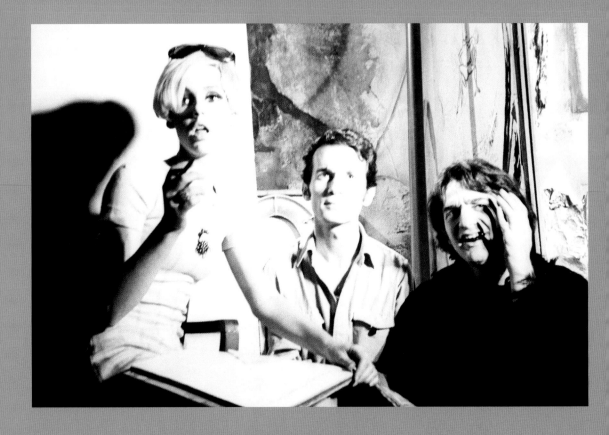

"Edie is 22, going wither, God knows, but at a great rate!"—*Vogue*

The Top of the End

Edie was the Factory's mental radio, tuning in a dozen frequencies. As friend and fellow tripnaut Huddler Bisby describes, Edie was the alpha alien:

HUDDLER BISBY (IN *EDIE*): With people doing it together, each drug experience is like a group hypnosis, like we tune to each other until we're one radio. But even so, there's got to be at least one professional specialist in the broadcast, an anchor, a source of stability. Edie was one of those people who held you down, kept you from going nuts, because it didn't matter to her that you were going fifteen hundred miles an hour, she was okay at that speed.

If you wanted to, you could recreate a day in December of 1965—word for word—from Andy's "novel," *a*. In its 450 pages, the daily raps, rants, and rhapsodizings of the Factory regulars are recorded verbatim, although you might need similar drugs to decipher some of this stuff.

As we observe, Edie, (named "Taxine" in *a*) and Ondine (pictured far right) are working on a board game about the hierarchy of Fame or the pecking order of the Divine Spark (amphetamine has, for all intents and purposes, elided the distinction between the two). Edie (T) and Ondine (O) debate for pages and pages how the mana of the unworthy individual diminishes as he slips down the rungs of the Ladder of Renown, so that, by #5, he's relegated to the Vegas Lounge Lizard level of fame, here called "Louis Prima Ti-vo."

The whole middle section of *a* is a dialogue between Edie and Ondine. Ondine rants on about a contortionist who can fuck himself and why boys' asses are superior to those of girls. The two of them rant on about Dylan, Pop Art, habits, LSD, Dante, hippopotamuses, salad, Irving the Wallow, vitamins, movies, Dorothy Killgalen, speech itself, and t-t-tomorrow. "And we're not stopping here," someone announces mid rant. "In fact, we better start drawing a diagram for the different levels of New York hell." And on and on they go, epic talkers all, and repetitious to the point of delirium.

BILLY NAME: She would get involved in these elaborate games that speed freaks get into—and she was into all this cosmic stuff. She didn't have an ordinary mind, didn't really yak or chit-chat or gossip. She was just extraordinarily brilliant. And this is the reason why the whole thing of her life became a tragedy, because there was no receptacle for her brilliance. People were always wanting to photograph her, but beauty you can always find. It was her mind that didn't have an outlet, it didn't have a place to express itself other than with amphetamine heads and that's the tragedy of it— only amphetamine heads would talk to her that way. And then you get ruined on the drug. But I loved her. She was a brilliant little angel incarnate.

By the summer of '65 Edie has become restless with her role in Warhol movies (which won't stop her from being hurt when he stops using her). She wants to get on with the next phase of her career, a brilliant future that everyone (except those who knew her) could imagine.

In July, Chuck Wein directs *My Hustler* on Fire Island. Edie is upset that she's been excluded— and from a film directed by her champion. Why had they chosen to shoot a gay porn movie instead of another film with her?

Throughout the summer, into fall, Warhol made more movies: *Camp*, *More Milk, Yvette* (aka *Lana Turner*) and *Paul Swan*, but none of them with Edie.

By fall, Edie is unhappy. She had become the star, the Princess of Pop, the diva of underground movies—but that's the problem. It's precisely these films, the ones that have elevated her to a level of avant-garde infamy and quasi-divinity, that are now bothering her. "Everybody is laughing at me. I'm too embarrassed even to leave my apartment," she tells Andy.

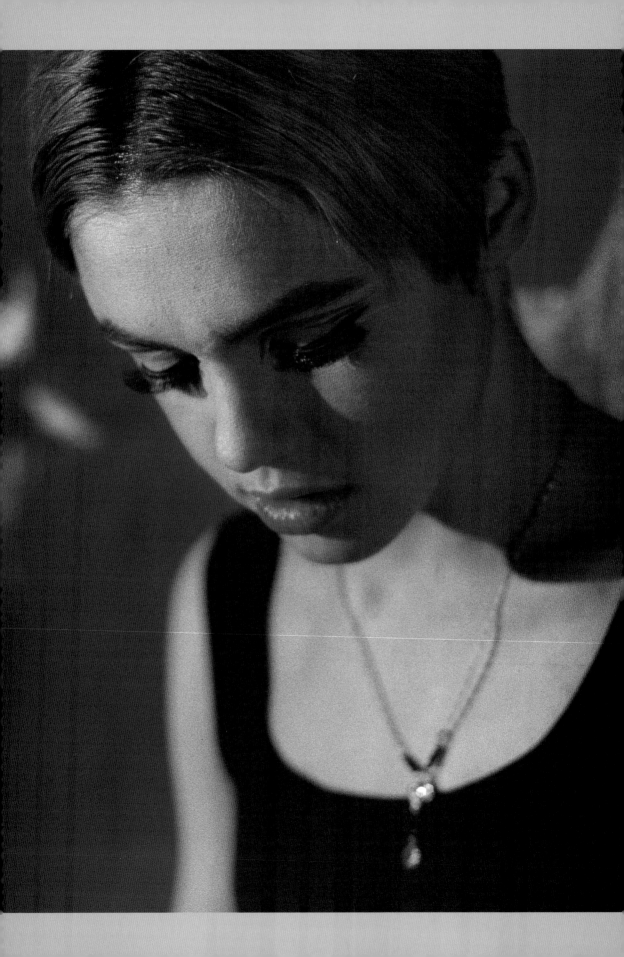

ROBERT HEIDE: All those movies with Candy Darling, Holly Woodlawn and Jackie Curtis—it's all about humiliating them. When Candy did Tennessee Williams' *Small Craft Warnings* on stage, she was marvelous, soft and dewy—a little like Edie actually. But when Paul Morrissey got a hold of Candy, he had her beaten up and doing horrible things. The transvestite comedies are a joke on women's liberation. The interesting thing is Edie was one of the few people who wasn't put in a degrading position as a woman in his movies, because Andy in some bizarre way identified with Edie.

"But, my movies are a joke," Edie whines to Andy on the phone. "They've made me into a joke." But "they were a joke!" Andy said, shortly afterwards, to Mel Jaffe at the Russian Tea Room. Jaffe, a reporter from *The Journal American*, who was a friend of both Edie and Andy, had been asked to mediate. It hardly helped the situation that absurdity was part of Andy's intention. "The whole idea of making the movies in the first place was to be ridiculous," he insisted. Edie just hadn't gotten the joke. A joke and art, of course—why would there be a difference? The Modernist is a juggler, hustler, con artist. The confidence man being the essential American.

BILLY NAME: That was part of the fun of Andy's movies—the joke of it. It's like you bake a soufflé and it falls flat—and that's the point. The art part is that you meant to do it. You did it deliberately. Nobody had thought of making movies like that before, making movies that were deliberately bad.

As Andy, in high Warholian mode, told the *London Observer*: "I want to do bad movies because too many people are doing good movies. The bad movies will be very good."

Head in Toilet

DECEMBER 1965

Lupe is the last film Edie will make with Andy before they split. Starring Edie and Billy Name, it was filmed in Panna Grady's apartment in the Dakota. Panna Grady was a culture hound of a very high caliber, holding wicked salons for writers and artists—preferably of the drug addicted, self-immolating kind—geniuses de la boue, saints of the lower depths, which made her pad the ideal place to film the Lupe Velez story.

Lupe Velez was the Mexican Spitfire, an exotic Hollywood comedienne of the '30s who lived in a Spanish style palazzo and played saucy Latin stereotypes. The daughter of a Mexican prostitute, she'd made a series of successful movies and had a number of disastrous love affairs, including one with Gary Cooper. By the early '40s her career was fading, and following yet another failed romance she decided to commit suicide, but in spectacular fashion. In the manner of her Aztec ancestors, she created a bird-of-paradise altar covered with candles, images of saints and movie stars on which she planned to sacrifice herself. She dressed in ceremonial robes, took a handful of Seconals and awaited the pale-skinned Aztec god Quetzalcoatl, who according to Mexican mythology promised his people that he would one day return to them from the Eastern Sea with his Jade Consort (La Lupe). Alas, her mythical union with the Plumed Serpent ended in grotesque farce. She began to throw up from barbiturate poisoning, ran to the bathroom, and, instead of her exquisite ritual death, died vomiting with her head in the toilet.

ROBERT HEIDE: Around the time they were to start filming I ran into Edie and asked her if she'd gotten the script of *Lupe* I'd sent, and she said, "Oh, yeah, I got that, but we already did that this afternoon." In other words they'd filmed it without looking at the script.

Lupe is not a grand costume drama—that would be too much like a Lupe Velez movie. It's just another real-time portrait of Edie, with a nasty twist at the end.

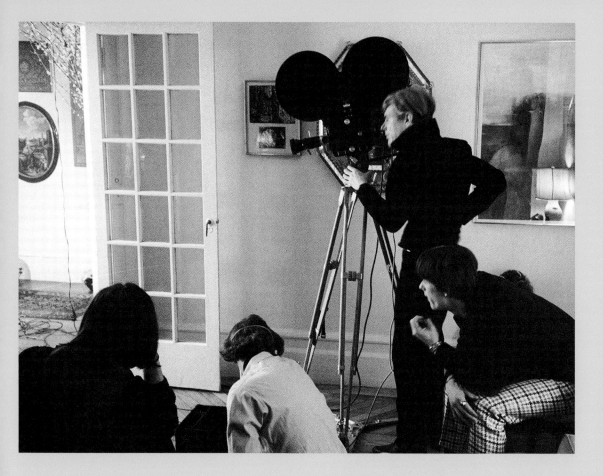

BILLY NAME: The first reel of *Lupe* is the whole Edie thing—Edie getting dressed or deciding what she was going to wear. Just Edie. I didn't expect to perform in *Lupe* at all. I was just there to take photographs, but we didn't know the first reel was going to be out of focus until we got the print back. In the second reel Edie was going to do the same thing over again, but someone must've said to Andy, "Why don't we have some other people in it?" And because I was there and I used to give people haircuts, Andy said, "Oh, gee, let's have Billy give her a hair cut." The second reel came out in focus. Then there's the part where she commits suicide—that was shot separately. We had Edie on the floor of the bathroom with her head on the toilet like Lupe overdosing. Then Edie was meant to vomit but wasn't able to. She died with her head on the toilet. That part was added on to the end of both reels. Andy showed the two reels simultaneously. It's ingenious, more like collage art than cinematic art.

Although most of *Lupe* centers around Edie being Edie and doing Edie type things—making herself up, doing her hair, talking on the phone, etc., and only the last three minutes involve the sordid business with Lupe's head in the toilet, the theme itself was clearly degrading. One thing was sure. Andy no longer saw Edie as his fairy consort.

Dylan

That same month, Edie meets Bob Dylan and Bobby Neuwirth upstairs at the Kettle of Fish, the grotto of the neo-folk religion. Dylan as Hamlet, Prince of Bleecker Street and Neuwirth as his hipster Horatio, a boulevardier, painter and Dylan's alter ego. Dylan the shapeshifter adopted Neuwirth's acerbic, cynical love-minus-zero persona as the prototype for the new model Dylan, the seething amphetamine visionary of the classic Dylan triptych—*Bringing It All Back Home, Highway 61 Revisited*, and *Blonde on Blonde*. Edie idolizes Dylan and begins a love affair with Neuwirth.

A week later, Dylan, Neuwirth, filmmakers D.A. Pennebaker and Richard Leacock, and entourage pay a visit to the Factory.

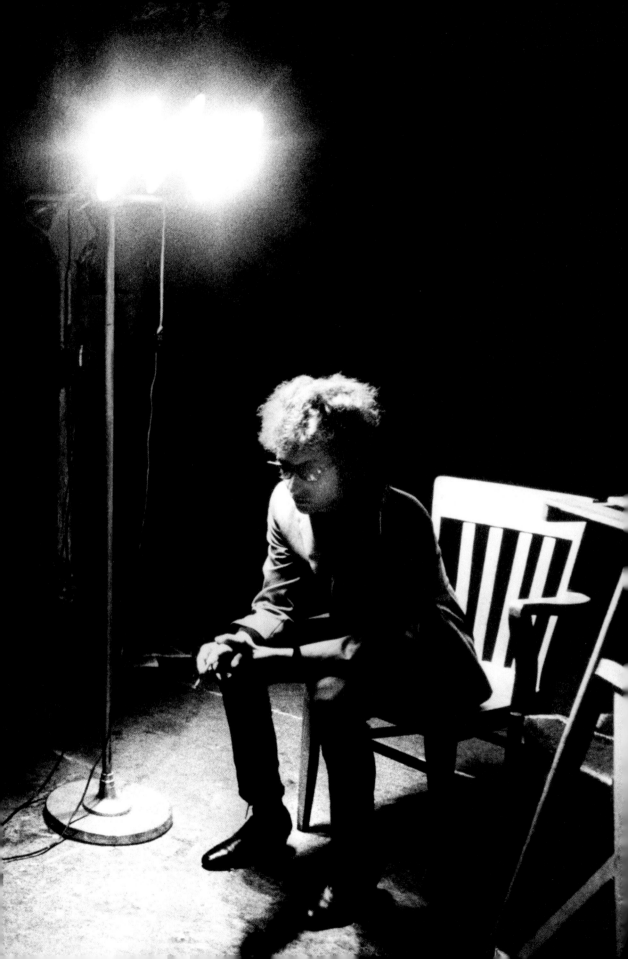

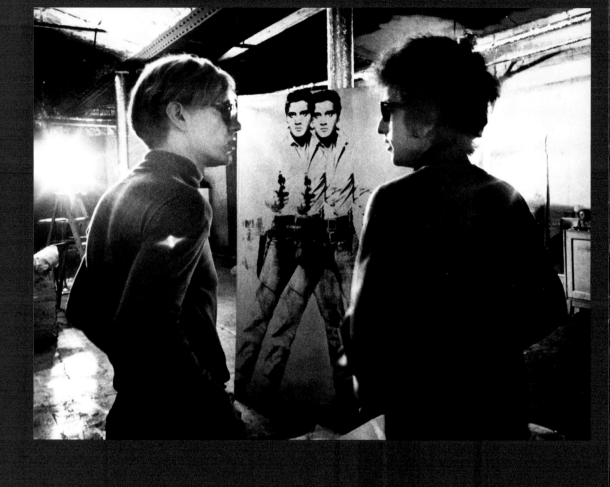

NAT FINKELSTEIN: The joint was atwitter, the denizens agog, "Bobby's coming, Bobby's coming." They reminded me of a Visigoth army: the men big and hairy, the women small and plain, arranged so as to set off Bobby like a rhinestone on an ass's forehead. The circus had come to town; it was hetero day at the zoo—carefully contrived and well orchestrated. They were sitting together, but their existence was predicated on being recorded. The scene reminded me of three merchant princesses done by some Flemish painter, and I shot them that way. A Jewish potlatch commenced. Andy gave Bobby a great double image of Elvis. Bobby gave Andy short shrift. Shooting and plundering finished, the Dylan gang headed for the door, me and my Nikon at their heels. They left as they had entered; acting as if the Jews left their doors open for Bobby on the Passover. They departed having tied Elvis to the top of a Woodstock station wagon, like a deer poached out of season. Much later, Bobby told me he'd traded the Elvis for Albert Grossman's couch.

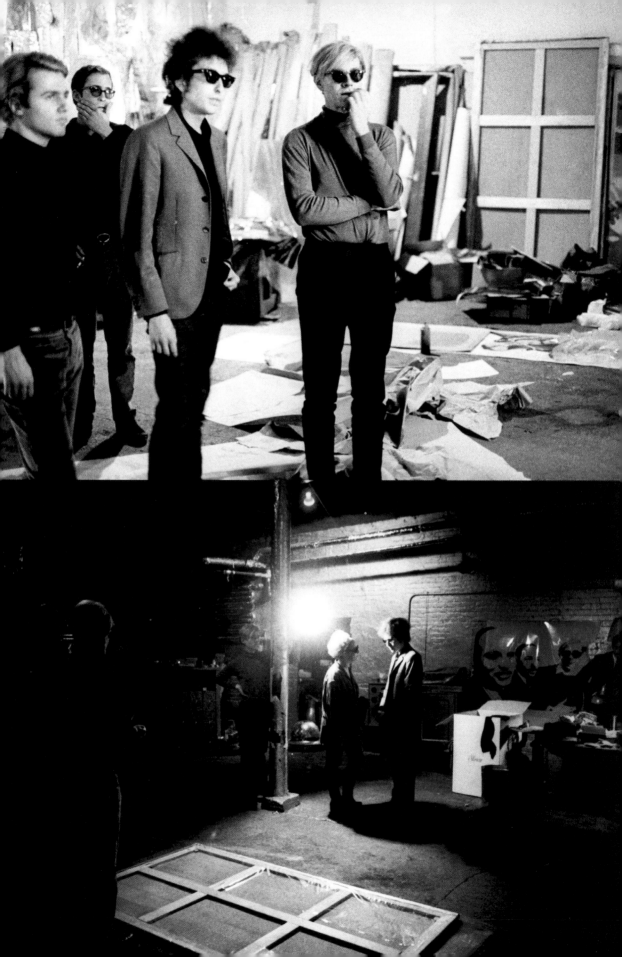

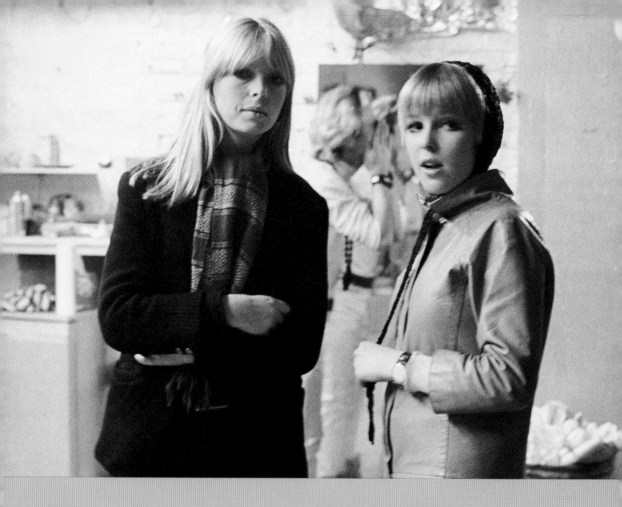

Femme Fatale

JANUARY 1966

Andy tells Lou Reed to write a song about Edie as a femme fatale. "Femme Fatale" written in the dumb/hip Lou pop mode, but as sung by Nico with the Velvets it's positively gothic—especially the line, "She's just a little tease" with its prolonged Teutonic "s."

JANUARY 13 1966

Warhol is invited to speak at the annual banquet of the New York Society for Clinical Psychiatry at the Delmonico Hotel. He brings the Velvet Underground with him with Nico as their lead singer—this is the first time she performs publicly with the band. Edie arrives with Bob Neuwirth. She attempts to sing with disastrous results. Demoralized, and believing that Nico is the new Warhol superstar, Edie knows her days with Andy are numbered. Nico fits in better with the new noirish Factory. Where Edie was bubbly, Nico is macabre. It's the last time Edie will appear officially with the Factory crowd.

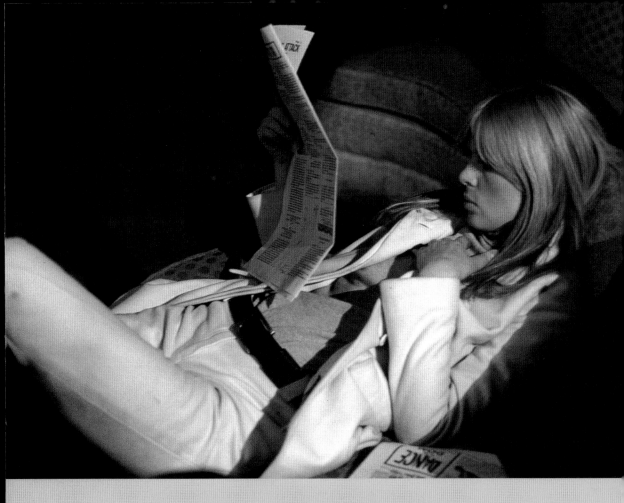

GERARD MALANGA: Edie in her mind wanted to be part of the Velvets, but there was no place for her in the group—she couldn't sing—so she jumped ship and went with the Dylan clan, and then she had a rude awakening. Nothing was going to happen with her singing career—or anything else over there. But she signed a contract with Albert Grossman—for whatever it was they were promising her and that effectively was the end of her relationship with Andy, because Grossman forbade her to hang out with Andy. She demanded her sequence taken out of *Chelsea Girls* and it was replaced with that beautiful final scene with the colored lights playing on Nico's face.

For some time, Edie had thought about leaving Andy and moving on. She wanted to be a star, she wanted to be Marilyn Monroe, but Marilyn, however fragile she appeared, was in some ways tough. And talented. Edie couldn't deal with the world outside the little family of the Factory. She'd go to meetings with Hollywood producers but would come away demoralized and freaked out. On page after page of a, Andy's "novel," you can hear Edie whining about "those assholes" and trying to persuade Ondine to accompany her to these meetings. "There's nothing in the world I want more than . . . that you could be there," she tells him. To which Ondine sensibly says, "You know it wouldn't work." A minute later she's about to throw it in: "It's like I have one more step to go and that's when I give up." "But we have to, we just adjust, my dear," Ondine tells her. But it's a step Edie can never take.

BILLY NAME: Originally Andy just wanted her to be what she was. To present herself. Paul started turning the screws on things. He had a Pygmalion complex. Also, she started in with the Dylan crowd. "You're supposed to be our star," Andy would say. "We're spending all this money making these films. Why are you playing with them?"

> Edie undergoes violent mood swings and changes of heart. At one point she thinks the Warhol movies have ruined her, next she thinks the movies are okay, rationalizing: "I don't mind being a public fool as long as I'm communicating myself."

ROBERT HEIDE: Edie and I were riding around in a limousine—it was obviously Bob Dylan's limousine—and that's when I first began to wonder what was going on with her and Andy. There was this conflict going on between Andy and Grossman and Bob Dylan, about making Edie into a movie star and a property. And she was, ostensibly, splitting from Andy, so there was a lot of anger and angst and resentment coming out of Andy. I mean, I could see it, this kind of nervousness and tension. The stress and the pressure on Edie was enormous, particularly when she got in the middle of the conflict between Warhol and Dylan. Andy was angry and jealous, and the way he showed it was by being very impassive—he could be really cold.

> Furious at Edie's defection, Warhol & Co. found themselves a new Edie in a 42nd Street bar. Ingrid von Schefflin, who had a similar Sasoon haircut, was a caricature of Edie, but a good enough sport not to mind.

ROBERT HEIDE: The joke was when Andy showed up with this Ingrid Superstar, who was supposed to be a threat to Edie. She was goofy, like she was right out of a Busby Berkley chorus line.

> Ingrid Superstar was the first of the comediennes—the clowns, drag queens, and other female grotesques—who would populate Warhol's later movies.

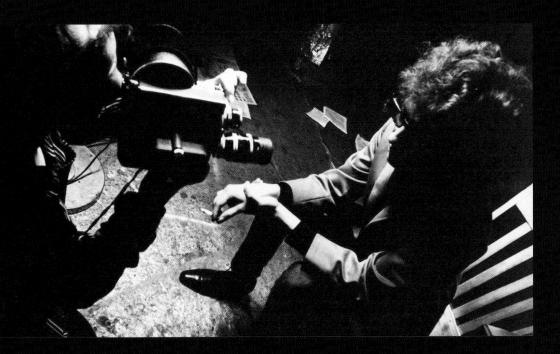

Withdrawal Symptoms

The Factory was a kind of tribe and its way of dealing with bolshy members was ostracism, exclusion, and isolation. The shunned ones came to bad ends. They danced out of windows, jumped off balconies, OD'd.

When the attention began to be withdrawn from Edie she went a little mad. Her oxygen was running out, she was fragmenting. Her crazed velocity, once seen as part of her uncanny charisma, now seemed a symptom of malfunctioning. Edie was someone who didn't exist outside the unit, the group, the umah. She was the Queen Bee of the hive. Her power came from the collective energy, from the adoration of her drones. When her long-dormant hysteria began to surface, she gave off waves of panic. "You could hear her screaming even when she wasn't screaming," Henry Geldzahler said of her in *Edie*. "This sort of supersonic whistling."

DANNY FIELDS: There was the prospect of a movie with Bob Dylan. But Grossman [Dylan's manager] never did anything with her. There was talk, most of it negative, about Andy. And they would say to her, "You know you can really go places, you could really be an actress, you're so beautiful, you're getting so thin, why do you hang around with that bunch of dizzy amphetamine faggots? They're not going to do anything for you." So I don't know if after that she turned her back in a huff. But, you know, I don't think Edie walked on Andy. I think he probably walked on her, what with her drug abuse, her perpetual stonedness. She became more and more absorbed in drugs. And she was having this all-consuming affair with Bobby Neuwirth.

Andy begins to hear stories that Dylan thought he had ruined Edie and blamed him for her drug problems. People tell Andy that Dylan is ridiculing him in "Like a Rolling Stone," that Andy's the diplomat who's taken everything from Edie he could steal. The only problem with this is that "Like a Rolling Stone" was written in the summer of 1965 and Dylan did not meet Edie until December of that year. In *POPism* Andy claims that he never gave Edie drugs, and you tend to believe him—he loved to have people around who were on drugs, but he had a morbid fear of the police, and at one point hung up a laughable sign in the Factory forbidding the use of drugs on the premises—good luck! In the numbingly verbatim transcript of *a*, Andy comes off as Mr. Anti-Drug. When Edie says goodnight, she begs Andy & Co. for drugs—"You know I can't sleep without Nembutals," and dear old auntie Andy tells her she doesn't need them. "Put on the TV," he advises her, "and just make your eyes tired and just go to sleep."

As to the charge, that you still hear, as to Andy destroying Edie, it stems as much from his sinister image as from anything he may have done to her. She was around the Factory barely a year, and, if anything, her destructive drug taking wasn't good for the movie-making business. "When people are ready to, they change," he says in *POPism*. "They never do it before then, and sometimes they die before they get around to it. You can't make them change if they don't want to, just like when they do want to, you can't stop them."

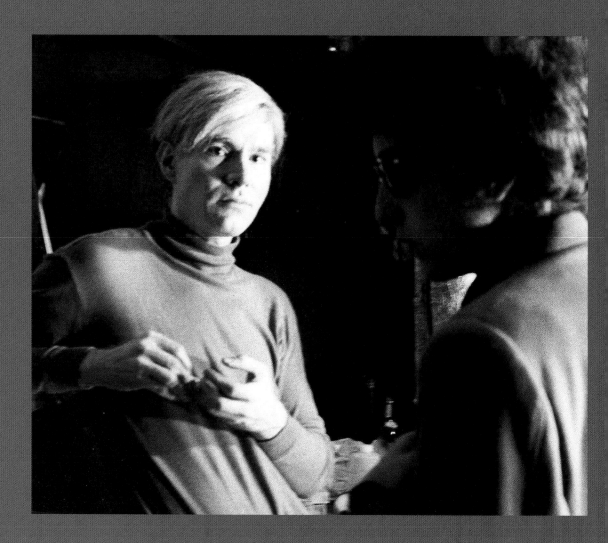

ROBERT HEIDE: I remember one moment with Edie that was a kind of turning point for her and Andy. Andy was going to be picking up some outfits from the Leather Man. He called me and said, "Meet me over at Kettle of Fish." He liked MacDougal Street, which happened to be, I think, the street where Bob Dylan lived, and the Kettle of Fish was, of course, Dylan's hangout. Edie at the time was involved with Dylan in some way—a movie project that his manager Albert Grossman was supposedly setting up and so forth, and this had caused some strain between Edie and Andy. I get there, and who's there, but Edie—Andy hasn't shown up yet—she's sitting there having a glass of white wine and there are tears running down her face. I said, "What's going on?" She just starts muttering, "I can't get close to him, I try to get close to him but he won't respond. I guess it's finished, it's over." I really didn't know what she was talking about, but it turned out she was upset about Andy, who could be very cold, especially when he felt people were moving away from him. Then Andy comes in with the box from the Leather Man and he's actually dressed in a blue suede outfit, and in his whispery voice says, "Oh, hi, oh, hi!" He's got dark glasses on, and I order a beer, Andy orders a beer, and we're sitting there and a few minutes later, this limousine pulls up, and in comes Bob Dylan—this was around the *Blonde on Blonde* period. Dylan walks over and sits next to Edie. Very little is said, but it's obvious there's this incredible kinship going on between them. Andy's looking over at them—if a look could kill—then he's looking away, and Edie's looking askance, and finally, after about 10 minutes go by with no one saying more than a couple of words, Dylan says, "Let's split!" Out they go and get into the limo. Andy said nothing. He just finished his beer and we left. You know it was that kind of thing around the Factory of always being super-cool, that cold side of amphetamines and not talking too much about feelings. I mean, that was what was unusual about Edie that day because nobody ever really talked about anything personal as far as I could tell. And that moment was the turning point. It was happening right then with her going off with Dylan and then whatever kind of abandonment he was feeling. Andy could be very secretive. He was terrified of any emotion of any kind. He was really a cold fish.

As to the Satanic Andy, the ghoulish predator of lost souls, he says: "Now and then someone would accuse me of being evil—of letting people destroy themselves while I watched, just so I could film them and tape record them. But I don't think of myself as evil—just realistic . . ." This is a bit disingenuous—there definitely was a creepy side to Andy.

ROBERT HEIDE: One day Andy was in the Village and wanted to go by Number 5 Cornelia Street, where Johnny Dodd, the lighting designer, lived (he also was dealing drugs, mainly marijuana, angel dust), that happened to be the spot where Freddy Herko had done this ballet leap out the window and killed himself—about which Andy had famously said, "Gee, why didn't he tell us? We could've filmed it." Right after that had happened I'd walked by there. They were cleaning up what looked like blood and pieces of brain or whatever, and I just kept on walking and I thought, whatever state I was in at the time, that must be somebody I know. We get there and Andy looks up at the window and I point to the exact spot and that's when he made this remark to me. "I wonder when Edie will commit suicide," he said. "I hope she lets us know so we can film it."

Andy had a morbid fascination with suicides, crashes, executions—the frisson of violent death, like those African kings who kept people about to die in their company so they could experience the spectral light of the proleptic dead, the tiny cosmic pings emanating from the otherworld.

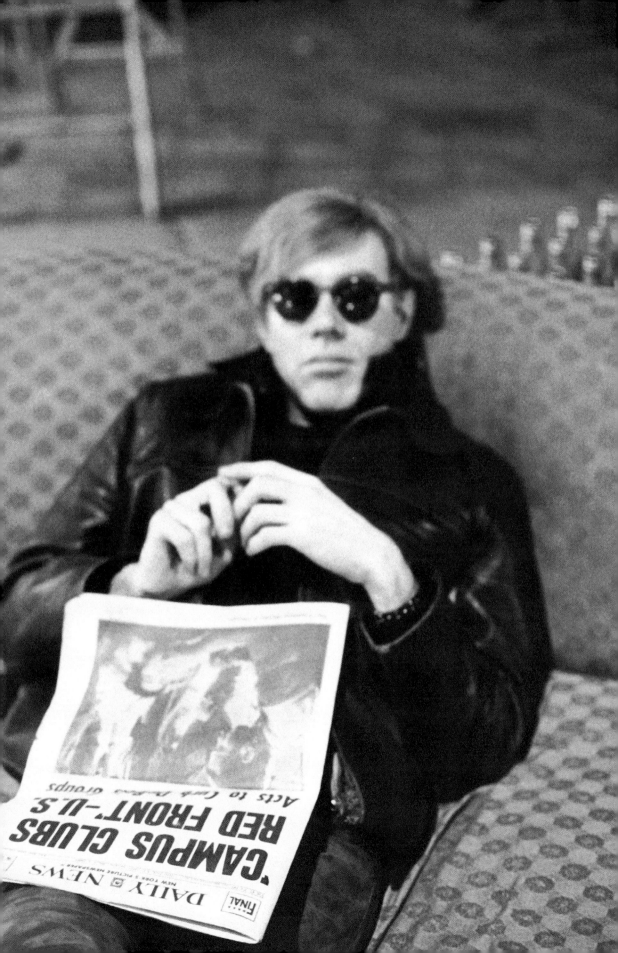

According to Gerard Malanga, the showdown between Edie and Andy took place at the end of February at Maxwell's Plum. The first act of defiance came when Edie refused to pick up the check—for some ten people, including Andy, Paul Morrissey, Donald Lyons, Ingrid Superstar, Barbara Rubin, Nico, Chuck Wein, Lou Reed and John Cale—as she was accustomed to doing. She launched into an attack on Andy. Where was her money from the films? Why hadn't she been made a part of the Velvet Underground? Andy said they weren't making any money from the films as yet and she should be patient, at which point Edie told him she was going to star in a movie with Bob Dylan. Andy, realizing Edie had a crush on Dylan, said, "Did you know, Edie, that Bob Dylan has gotten married?" (He'd married Sara Lownds in a secret ceremony in November 1965.) Edie was stunned, went to make a phone call and came back trembling, realizing that Dylan and Grossman had been leading her on.

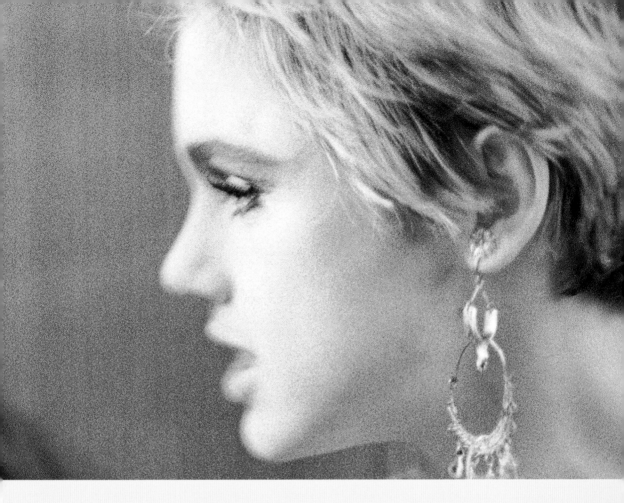

GERARD MALANGA: You know something? Edie got taken, okay?
Edie was a very impressionable person. In a good way. Sweet and innocent.
Somebody was playing Machiavelli. I think it was Bobby Neuwirth.
He has changed his tune, thank god. But he was such a bad influence
on Dylan. Dylan picked up so many bad habits from Bobby Neuwirth.
Edie didn't know Bob Dylan was married to Sara at the time. She thought
she was going to be a part of the Bob Dylan clan, and it is a clan, like the
McCoys and the whatevers—us, the Factorites. In Woodstock, they made
Edie feel they were going to launch a singing career for her. But she didn't
sing a note and when we did the gig with the Velvet's for the psychiatric
convention, Nico had just come on the scene and Andy had put Nico
together with the Velvets. So what was Edie going to do? Did Edie want
to be a whip dancer on stage? That wasn't her role in life. What was left
for her in that scene was getting a little humiliating for her.

The Ghost of Electricity

In *Edie*, Neuwirth says he felt she was wasting her time making "fatuous Warhol movies." Neuwirth made a short, "Chaplinesque" film of Edie pulling her leather rhinoceros on roller skates up Fifth Avenue during the Easter Day parade, with the cops pretending to give her a ticket for an illegally parked pachyderm. The trouble with this Holly Golightly approach was that it was too cute and Edie was already a cute item to begin with. You had to play Edie against the grain, otherwise you ended up with whimsy.

BILLY NAME: Edie had this big, torrid love affair with Bobby Neuwirth where she and he would just get so blasted on amphetamine that they were cooked days on end. So she got herself so wired out on that scene that it was really no longer practical to be working with Andy because when you work with Andy you have to be relatively intimate with him. Her total energy for this whole period was Bobby Neuwirth, and it wasn't even anything that most people knew about. I only knew it because I would go over to that new little apartment she got where Ondine was her French maid serving her breakfast consisting of drug paraphernalia and a saucer filled with speed.

Dylan had held out the possibility of making a movie with Edie, but his attempts to implement his mystical cinematic romances—like *Renaldo and Clara*—have always been problematic. Film, even at its most elusive, is far more explicit than song lyrics—especially Dylan's—and thus would not fit well with his finely tuned mystique. The source of Edie's charismatic energy came from the attraction/repulsion impulse of sexless affairs (which mirrored the relationship with her father). Dylan saw that Edie might be an ideal foil to play opposite him. As with Andy, her opposing spin and charge would animate them both. But as the months went by, it was clear that a Dylan film was never going to happen.

In a sense, Dylan did make a movie—several movies—with Edie. His film noir, *Blonde on Blonde*, with its phantasmagoric night world of freaks, the lost, hipsters and hustlers seems spun out of the phosphorescent nightworld that Edie inhabited. All those strange places you find yourself at in the middle of the night with people you barely know doing strange things and you're too stoned to leave. For Dylan, as a materializer of mythical imagery, Edie was an irresistible type, the doomed, elusive damsel seen through his nightvision. Edie populates *Blonde on Blonde* as its unstable object of desire. She is the unattainable neurasthenic woman, the silly fashion-mad debutante, the disturbed lover, the seductive drug geisha whose infectious gravity could pull him into the underworld.

Although inadvertent, Warhol's comment on Dylan in the *Diaries* is actually a compliment to Dylan's uncanny ability to conjure up scenes and inhabit other people's consciousness: "He was just mimicking real people and the amphetamine made it come out magic. With amphetamine he could copy the right words and make it sound right."

DANNY FIELDS: It was said he wrote "Leopard-Skin Pill-Box Hat" about her. You know she did have a leopard-skin pill-box hat. She also had a leopard-skin coat, which I gather she stole from someone. She left the hat in my apartment—that was my one memento of her. I gave it to Justin Barnes who does a wonderful Edie Sedgwick performance thing. People say there are all kinds of songs Dylan wrote for Edie. I think if you ask Dylan who he wrote this or that song about he wouldn't know. I think this is all sort of apocryphal now. I think it's one of those things. There's no truth, there's no history, there's no memory. Especially when you're talking about things from 40 years ago.

True enough, but I can't stop thinking about the heroine of "Just Like a Woman," with her fog, her amphetamine and her pearls. If that isn't about Edie I'll eat my hat. But then, again, Allen Ginsberg once told me this song was about him.

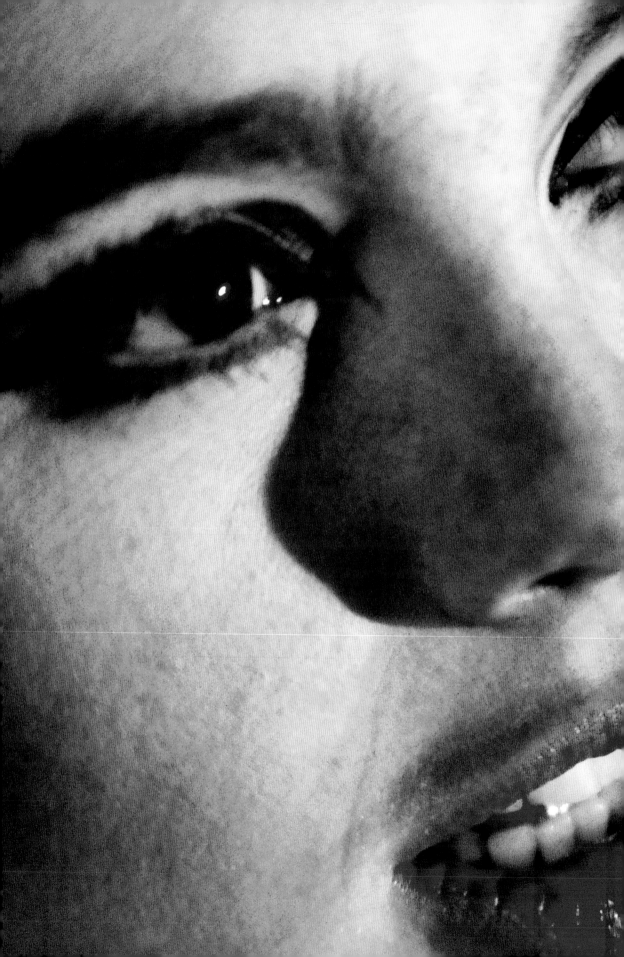

HIGH FASHION PHOTOGRA-
PHERS WERE CRAZY ABOUT
EDIE, MAD ITALIANS COOING
"YOUR FACE IS A MOON OVER
CAPPADOCIAN MOUNTAINS"
WHILE STROBE LIGHTS
FLASHED AND CHEEKY
COCKNEYS URGED HER TO
"USE ME, BABY!"

Fashion Free Fall

Well, if she couldn't sing and no one was going to put her in a movie, she could always model. Edie signed up with the Ford Modeling Agency. She was a model, the model of the day, but one who transcended the category. Edie's style was her own; her clothes, her hair, her earrings all became part of her personality (something quite different from the chameleon-like images professional models project).

She was uncannily photogenic, a "Youthquaker" (in the fashion-speak of the time), the epitome of that mid-'60s spark and shimmer. Edie always had on whatever was the latest fashion, the coolest boots, the best that money could buy, and carried it all off with amphetamine aplomb. She seemed to be plugged into direct current—even if it was from a psycho-pharmacological source. "The secret of her charisma" as Huddler Bisby points out in Edie, "was that she was only really beautiful when she was running not just at fifteen miles an hour, or fifty, or eighty-eight, but at fifteen hundred."

Along with Twiggy, Edie, with the asexual body of a 12-year-old boy, was one of the first child-women, a forerunner of Kate Moss (in more ways than one) and countless others. What could have been a more perfect match than Betsey Johnson, the Mod designer, who said things like, "What would you wear to the moon?" and Edie, the emblematic wild child from an age of extremes. All the old rules were thrown out. Futuristic, theatrical, playful, child-dressing-up clothes. Betsey Johnson's body-conscious clothes, the famous Julie Christie dress—basically a t-shirt mini-skirt—and wasn't Edie the very imp of the t-shirt and tights look? A slave to fashion, you'd find Edie—mid-summer or mid-winter—in her black tights and t-shirts. It wasn't clothing, it was her second skin.

Edie became Betsey's fitting model and Betsey began to model herself on Edie. Zipped into Betsey's mini-tanks and silverfish dresses, Edie is the essence of '60s style, a moment in time encapsulated in fashion and attitude.

The editors at Vogue were infatuated with Edie; they wanted to devote an entire issue to her, but her reputation as a feral creature of the night made the Little Sisters of the Immaculate Frock nervous. Not that the use of drugs bothered Diana Vreeland, the grand dame of Vogue, herself: "I've never seen anyone on drugs that didn't have wonderful skin."

As self-possessed as she was, Edie apparently didn't think she was beautiful—or beautiful enough. Although it's hard to believe that her meticulous attention to her maquillage—the white lipstick, the huge bat-wing eyelashes, the kohl-dark eyeliner, the "moth look"—came from insecurities about the way she looked. Patient as she was about make-up, Edie didn't have the patience or discipline for modeling, and being a model was very different from being a Warhol superstar. You're a mannequin; it's not really about you, it's about the clothes, and it's boring in quite a different way than a Warhol movie is boring.

OCTOBER 1966

Edie's habit of burning candles, offerings to the Unknown God, and falling asleep with a lit cigarette—led to a lot of little fires and two serious ones.

DANNY FIELDS: Two of her apartments burned up completely. She escaped the flames by crawling on her stomach towards the door and reaching for the door knob. Both times the door knobs, at the Chelsea Hotel and at the 63rd Street apartment, were red hot and she burned her hands badly.

In the middle of the night her curtains on 63rd Street catch fire, she's badly burned and taken to Lennox Hill Hospital. Superstitious, with a keen ear to the knock of doom, she knows fires aren't just accidents, they're forebodings. As she tells her friend Judy Feiffer: "I have an accident about every two years, and one day it won't be an accident."

NOVEMBER 1966

A year after Edie and Andy made *Lupe*, Andy decides to do a movie—eventually titled *The Andy Warhol Story*—with the poet and scenester, René Ricard playing Andy. Ricard wants to do it with Edie, but, on heroin and sleeping pills, the sparkling, incandescent Edie of the silver Factory has wilted. "When she was with the fairies," Ricard says in *Edie*, "she was on speed and she was Edie, she was on." But when she arrives, sedated on downs, wearing a Marimekko shift, they are

Meanwhile Chuck Wein has been raising money for another Andy Warhol movie, *Jane Heir*, a re-imagining of the Charlotte Brontë story with Edie as the heroine, to be filmed on Huntington Hartford's Paradise Island. He manages to come up with a hefty budget for an underground movie, but Andy absconds with half of it, and Edie gets her hands on much of the rest. Chuck tracks her down in a boutique and, totally out of it, she's spent all of it on clothes. When he says, "But Edie, this money was for your *Jane Heir* movie!" she looks at him quizzically and asks, "Who's Jane Eyre?"

CHRISTMAS 1966

Edie goes home to Santa Barbara an alien. Her brother Jonathan is unnerved by her habit of anticipating what other people are about to say. Wobbly, erratic, and unplugged from her artificial energy, she appears mildly psychotic. She tries to explain that she needs diet pills to balance her precarious psycho-pharmacology. They put her in the County Hospital.

Neuwirth gets her sprung, but back in New York things only get worse. She is not the first person ever to see, from the windows of the Chelsea Hotel, monsters swimming up through the murky air, taunting her with the fatal slippage of mind and body. She becomes frantic. "Edie was desperate because she felt her edge was going," Neuwirth said in *Edie*. "I couldn't believe that someone of such intelligence would mistreat herself to that extent . . . it was caused by desperation and a lack of outlet for that incredible energy." Unable to deal with her headlong plunge, Neuwirth splits.

Her affair with Neuwirth was the "only true, passionate, and lasting love scene" she ever had, she says on the *Ciao! Manhattan* tapes, "and I practically ended up in the psychopathic ward . . . I could make love for forty-eight hours, forty-eight hours, forty-eight hours, without getting tired. But the minute he left me alone, I felt so empty and lost that I would start popping pills." Edie becomes distraught and suicidal. Her infernal twin demons, sex and drugs, take turns tormenting her by passing her off from one to the other. To console herself for the breakup with Neuwirth and wean herself off amphetamines—rationalization comes with the territory—she starts using heroin, her new demon lover. In the past her demons had fueled her supernatural powers, but she is exhausted, at the end of her tether.

Factory Close-Out

JANUARY 1967

The building that housed the Factory is being pulled down and Warhol moves his base of operations to 33 Union Square. Although it is downtown, it looks very uptown, more like a chi-chi PR office than an artist's studio. Edie wouldn't have fit in to the new white, antiseptic Factory with its sign in the lobby—and this time they meant it:

PLEASE TELEPHONE TO MAKE OR CONFIRM VISITS, APPOINTMENTS, ETC. NO DROP-INS. ALL JUNK OUT!!

The new Factory was a tea party for poseurs, pretty boys in Commes des Garcons suits, hysterical social climbers, trust fund dilettantes, punctilious little amanuenses, self-important archivists, the ephebes, the goofily impressionable Bob Colacello always on the verge of fainting at the delicious condescension of the Lady Catherine de Burghs of high society (but who later wrote a wonderful book about Andy), the absurdly snobbish Fred Hughes, bowing and scraping in his dandyish suits on bended knee before any heiress and all of them believing they were actually taking part in the legendary fab-ul-ous Factory. This new Factory was a boutique, a mausoleum, a recreation of a scene of infamy and creativity by corporate hipsters. Sic transit gloria Andy!

The Ghouls Move In

In the spring of 1967 the infernal machinery of *Ciao! Manhattan*, her final movie, cranks into gear. It's a gruesome film, not only because of the flagrant exploitation of someone in terrible mental and physical shape, but also because it revels in her sordid state with repellant voyeurism. It tracks Edie's disintegration with unseemly relish, getting her to undergo humiliating recreations of her shock treatments, speed shots, and utter degeneration. Edie is too drunk and pilled-up to notice that she is the subject of these serial humiliations. That she agreed to undergo them only testifies to her pathetic state of mind. The smarmy abuse of someone so vulnerable and incapable of protecting herself is disturbing. Worse, its sordid point of view forces us to read her life backwards from these final mortifying scenes, in which Edie lurches from one degradation to the next.

GERARD MALANGA: How she ended up sequencing into John Palmer and that awful *Ciao! Manhattan* movie guy [David Weisman] I don't know. I was out of the loop on that. She was a sweetheart. And got taken advantage of by a lot of people and it just went on and on till the day she died.

APRIL 15 1967

In an outtake from *Ciao! Manhattan* shot at the Be-In in Central Park's Sheep's Meadow, the once athletic Edie is so out of it she is unable to climb up a large boulder and instead is hauled up like a wounded animal. No wonder the producer Robert Margouleff's dog ate much of the early footage. Edie is clearly so out of it, it's painful to watch, like a somnambulist being manipulated through some sleazy voyeur's idea of an underground movie.

The *Ciao! Manhattan* project was initially financed as a skin flick with the early sequences directed by Chuck Wein in the middle avant porn manner of Warhol/Morrissey movies like *Flesh* and *Trash*. Viva, Paul America, Richie Berlin and Edie taking part in an orgy on the rubber raft—a kind of inflatable ship of fools—with reinforcements of tequila and intravenous drugs. At this point in the film the exhibitionism and the narcissism are still perfectly in synch and the participants ecstatic. Said Richie Berlin: "I intend to die in Chuck Wein's film."

Voodoo Fire

There are the ongoing phantasmagoric scenes, so extreme as to seem to have been invented by an over-zealous scriptwriter intent on recreating the '60s at its most excessive: Edie at the Scene rummaging through her bag with make-up, pills, hypo needles while Jim Morrison gives Jimi Hendrix a blow job on stage.

And then, like some ominous messenger from an elemental realm, another fire. This time in her room at the Chelsea.

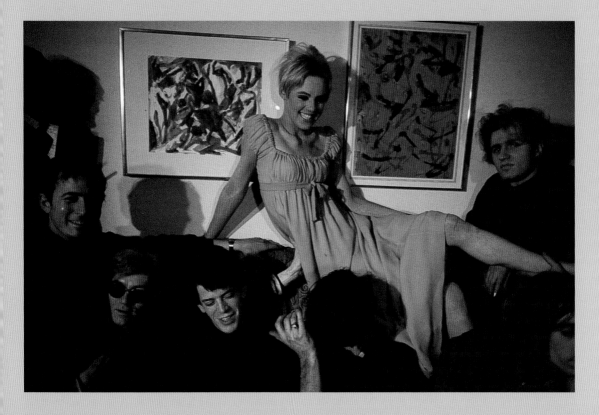

DANNY FIELDS: After the 63rd Street apartment burned up, she moved into the Chelsea. Leonard Cohen was staying there and I brought him down the hall to the room where Edie and Brigid [Berlin] had been hanging out. I guess they'd been doing amphetamine because the floor was covered with jars of sequins and magic markers. Brigid had passed out onto an open jar of glue and was stuck to the carpet. She didn't even know it, she was sleeping so soundly. But when she tried to roll over, she was glued to the carpet. Edie was blithely putting on her make-up. There was a store on 22nd and 7th, a voodoo shop, a magic shop or something. Edie was a very good customer there—or shoplifter. She had bought a bunch of candles and had put them on the mantel. "Oh Edie will be right out," I told Cohen. And he said, "This is a very unlucky arrangement of candles." Of course, I wanted to know why, but he just said, "I know these things. I know about magic candles." I can't remember which was shorter or longer or which was fatter or skinnier. I don't know how you can recognize an unlucky arrangement of like nine candles on a fireplace, but he said, "You should really tell her not to do this." "Leonard, you tell her," I said. "I'm not getting into this with Edie." So they met, and of course they knew to be impressed with each other. They were supposed to be impressed with each other. Then I asked Leonard Cohen to tell Edie what he'd told me about the candles. "Oh, it's in the Sioux religion or the Navajo world, or something," he said. "It's considered bad luck to have this particular combination of candles." "Oh, it's only a silly superstition," she replied, and the next day the room burned down.

There's a big outdoor party scene at a mansion in *Ciao! Manhattan* with Allen Ginsberg in the nude with beads and actors in bizarre costumes designed by Betsey Johnson.

BETSEY JOHNSON: A group of Andy's filmmaker offshoots were making *Ciao! Manhattan* with Edie, a movie that later butchered and embarrassed the whole sixties period. They wanted me to design some costumes to be used in an LSD scene. For the hallucination sequence I made bizarre Martha Graham type net numbers with buckram appendages sticking out all over them. My fitting model for the guys' costumes was the hotel receptionist, a tall, thin, very proper gent but he loved getting into my second skin outfit with strange attachments and silver buckles all over it. We would dress up in the costumes, sit sedately in the lobby of the Chelsea and wait for reactions from the residents. Hardly anybody noticed.

Andy, at Ondine's urging, makes one last attempt to film Edie. This is *Ondine and Edie*, a hopeful reprise of those telepathic speed dialogues between the two of them in a. But Edie is no longer the zeitsprite of the Factory. Despite her brave attempt to summon up the old enchanting sulfate-charged Edie—gossiping, doing impersonations, smoking (once one of her most effective gestures)—none of it works. The actions, the talk, are there, but something has gone dead inside and the effort to resurrect the charismatic imp of herself seems desperate. Ondine described it in *Edie* as "absolutely the most excruciating piece of footage you'll ever see in your life. It's a whole reel of the total collapse of a person."

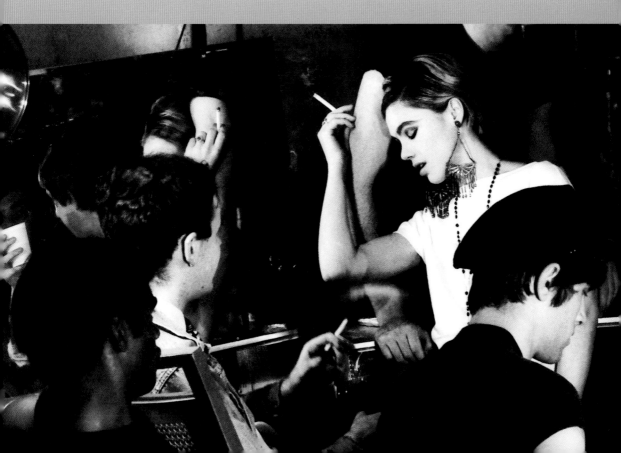

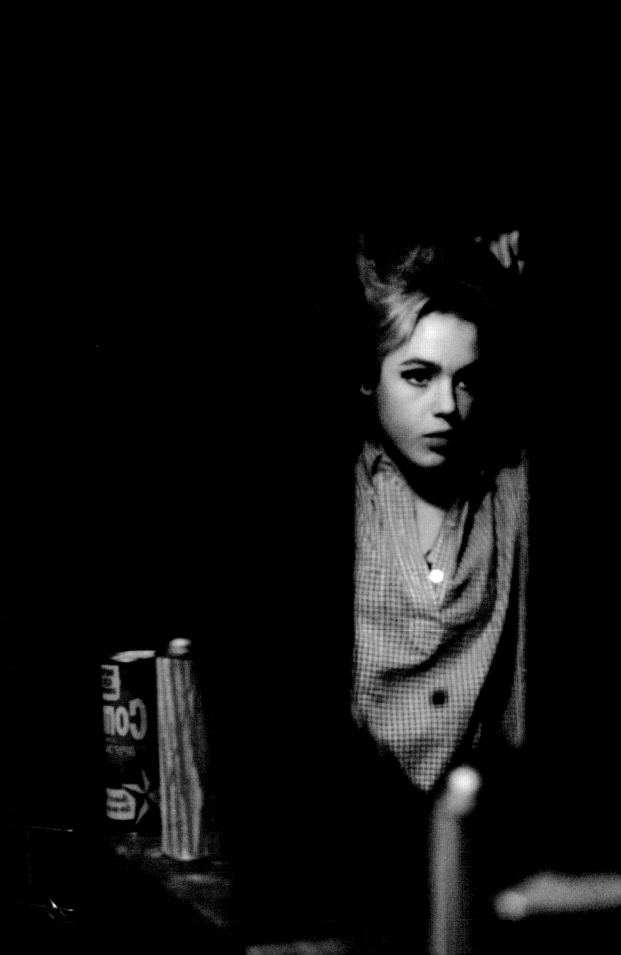

The Vanishing

As quickly, as suddenly as Edie had come on the scene, she disappeared. As Galatea to Warhol's Pygmalion, she was around for barely a year (March 1965 to February 1966) in her classic indelible form—and then she vanished. But not in a puff of smoke, the way goddesses vanish in mythology or in the movies. She disappeared back into the pod from which she had evolved in much the same way Michael Renee disappears into the portal of his spaceship in *The Day the Earth Stood Still*.

The person, Edith Minturn Sedgwick, remained. She lived on at the Chelsea setting fire to rooms, the way goddesses tend to do, careless of cigarettes, money, themselves. She was a mystery even to herself. The legendary Edie just ... vanished. Perhaps returning to her home planet. She fervently believed in teleportation, telekinesis—stuff you would expect an alien to believe in. My sister, Sarah, ran into the post-Edie Edie shortly before Edie drove west with friends in a VW bus.

SARAH LEGON: Edie wanted us to be friends—she felt somehow that I would be a "good, reliable" friend. She talked a lot. I remember her saying she believed you could physically move from one spot to another just by thinking about it—telekinesis, I think it was. "Like remote viewing," she said, "where you can use your mind to go to distant places and see what's there. It was developed by the CIA to obtain information on an unconscious level. If we just let the mind follow its own intuitive powers we can do anything. We're just atoms, so why couldn't we transport our bodies to anywhere we focus on? San Francisco or Tokyo or Mount Everest. We're just not evolved enough yet." Anyway this was a big thing to her and she believed it could and would happen. When I left I promised I would be in touch, but you know how it is. I think I may have gone off to Paris soon after, but in any case it wasn't long after that Edie went to California.

Edie and Nico Out West

SUMMER 1967

Edie drives west to California with friends in a VW van.

DANNY FIELDS: I was in Los Angeles and I had checked into the Tropicana. Paul Morrissey found me there and said, "Edie and Nico are staying at the castle," you know, the house on Glendale Drive across the street from that wonderful Frank Lloyd Wright Aztec Palace. The castle was the house on the haunted hill in a Vincent Price movie. It's kind of a spooky place and Edie and Nico were there alone and afraid, so we moved in with them. This is when I kidnapped Jim Morrison, which took some time and effort. I brought him over there and fixed him up with Nico. Edie was having an affair with Dino ("Come on people, smile on your brother") Valenti. As we drove up to the house she was saying good-bye to him; they were locked in an embrace in the covered entranceway. Once inside I said, "Oh I'm going to unpack and leave my stuff. What bedroom should I take?" You can imagine asking that of Nico and/or Edie! They just pointed vaguely. So I took a bedroom and quickly unpacked my drug stash and put it somewhere really good, and sure enough the next time I went to look at it, it was decimated. Edie had found it; she could sniff out who had drugs—how, I don't know. She'd had the decency to leave me enough for me to comatose Jim Morrison that night, but the next night she went for them again and found every last pill.

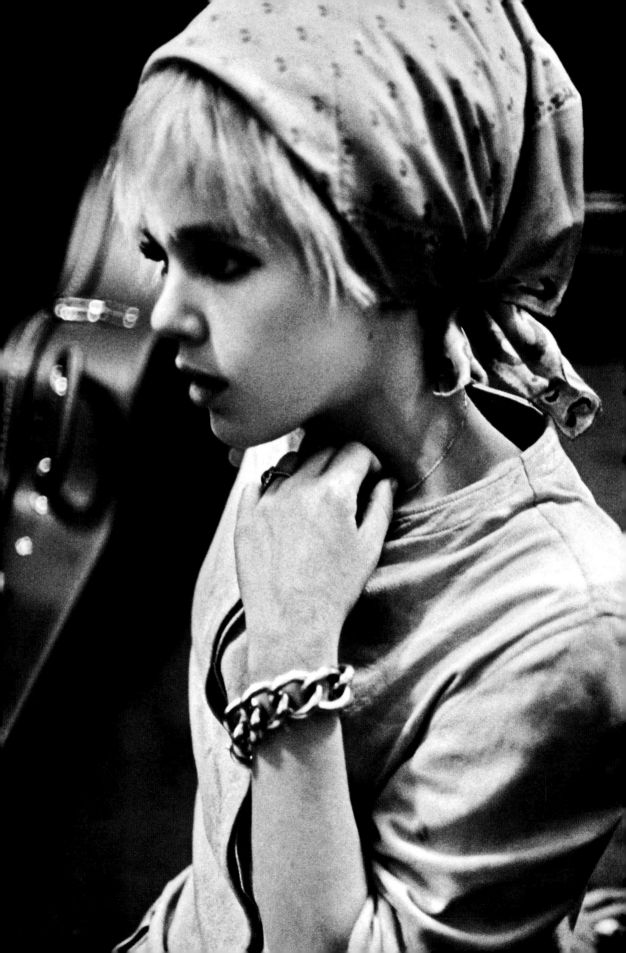

Saturn Devours Children

CHRISTMAS 1967

Fuzzy is dying of pancreatic cancer. Ruefully admitting he is the cause of his children's problems, in a fit of remorse he sends out Christmas cards of a painting by Goya depicting Saturn eating one of his own children.

Back in New York, Edie hears of Fuzzy's death while in Gracie Square Hospital. The terrible old dragon was dead; it would free her from the Sedgwick curse, from the terrible link with the abusive father. But friends who believed Fuzzy's death should have been a release for Edie misunderstood their relationship. Fuzzy was her malign counterweight. Once he was gone, her engine stopped. In a bizarre incident—even in the strange and haunted life of Edie—she goes through a full dress rehearsal of her own death.

A creepy doctor takes her to a motel where he shoots her up with LSD. "It's the middle ages and I am a princess." The next minute she wishes she were dead (in the way that one does on acid). Back home she has a few Bloody Marys and 15 Placidyls, her eyes roll back in her head, she goes into a coma and is declared DOA. Then, miraculously, she revives. She's put into Manhattan State Hospital, a building so numb and foreboding it looks like it's on Thorazine.

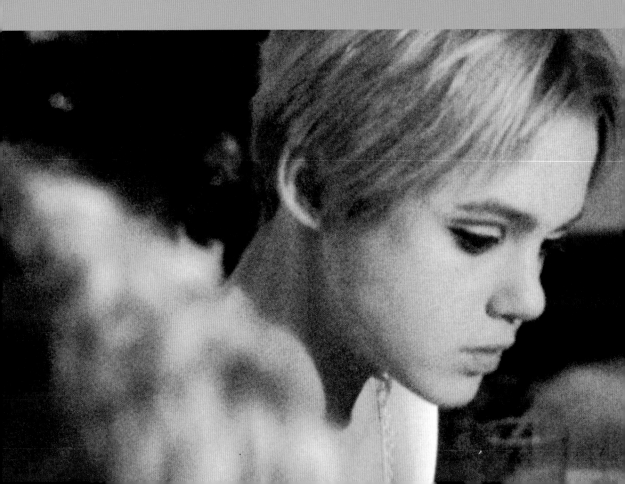

Psychic Disintegration

LATE FALL 1968

Edie's mother takes her out of Manhattan State Hospital and brings her back to the ranch. Her motor functions are gone, she's physically disintegrating. Her brain is fragmenting, she's lost the power of speech. Spaces appear between words, phrases, now between syllables—language collapsing in on itself. She can speak only in clogged consonants: "kk . . . kk . . . ggg . . . ddd." As in the Hebrew alphabet, the open-mouthed vowels, with their mystical connection to the invisible realm, have vanished.

At the ranch she painstaking begins to reconstruct the damaged parts of her brain, but she has hardly foresworn speed or her magical practices—the two, in Edie's case, are barely distinguishable. Even while falling apart, she still possessed uncanny and disturbing vatic qualities associated with ecstatics:

JONATHAN SEDGWICK (IN *EDIE*): Edie had this other trick of being able to talk your sentences as you said them . . . I couldn't get my words out fast enough. I couldn't beat her. She had me . . . it was a lesson . . . and I wanted to learn it . . . to be in the now, like Christ in the Mount Olive speech.

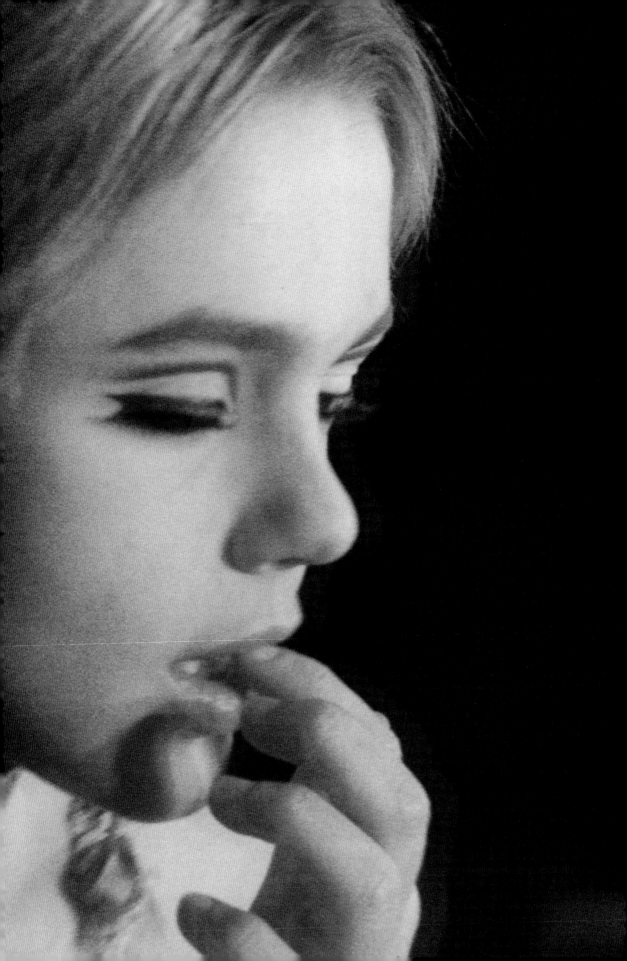

What is the correlation between mental disturbance, drugs, and revelation, anyway? She hears voices, speaks in tongues, receives stigmata, and practices telepathic thought transference. Past, present and future melt into a seamless continuum. As if her imaginary world has inextricably fused with reality, gossip, and the news, her fantasies begin to take on a fairy tale dimension. She conceives a mythical pregnancy, the imaginary child she had with Bob Dylan. She had been on the motorbike with Dylan when Dylan had his crash and she lost the baby. They'd put her into Bellevue and made her abort it because of her mental state. Dylan had put her into his mythology, she reasoned, so why couldn't she inject him into hers? Meanwhile, in her mind Warhol had become a cruel, avenging anti-Christ, a "sadistic faggot," a sinister warlock who turned his minions into automatons and robots. She imagines him as a thug in boots with a whip—finally conflating Andy with her father. She had become unreal even to herself. She speaks about herself in the past tense and in the third person: "They devoted an entire issue of *Vogue* to Edie," and "Edie was the biggest superstar of the '60s."

The atmosphere darkens. Things become grimmer and grimmer. She enters her own gothic Hell, populated with hideous caricatures summoned from the lowest strata of the soul. Bikers, hustlers, neo-Nazis, swarm around her like the menacing grotesques from a medieval painting. The graves have opened and half-human, half-decomposed creatures have come to claim her. It was almost as if, while still alive, she was undergoing the infernal horrors of the damned predicted in Jonathan Edwards' sulphorous sermons—a wriggling bug tortured by the matches of God. Edie, naturally, is unfazed, loves it all, regardless of the squalor and the humiliations. It's another adventure, even if it involves getting raped and trading sex for drugs.

BIBBE HANSEN: IN EVERY ERA, THERE HAVE ALWAYS BEEN PEOPLE WHO ARE ILLUMINED FROM WITHIN, POSSESSED OR BLESSED. IT MIGHT BE YOUR GREAT AUNT OR THE WOMAN WHO HAD THE HOUSE ON THE TOP OF THE HILL, BUT UNLESS SHE WAS AN ACTOR OR A FAMOUS ARTIST WE NEVER GOT TO SEE THOSE SHOOTING STARS. THE DIFFERENCE BETWEEN EDIE AND MANY OF THOSE UNIQUE PEOPLE WHO'VE FADED FROM MEMORY WAS THAT ANDY WAS THERE TO SHINE THE SPOTLIGHT ON HER AND CAPTURE HER. WITH THE COMING OF THE DEMOCRATIZATION OF CELEBRITY— WHICH ANDY PREDICTED—MANY MORE OF THESE UNUSUAL PEOPLE WILL COME TO BE KNOWN AND APPRECIATED. EDIE WAS THE FIRST REAL EXAMPLE OF THAT, AND SHE QUITE ROSE TO THE OCCASION.

Ciao! Edie

"She'd ball half the dudes in town for a snort of junk," says Preacher Ewing, her "consort" at the time. But Edie the consummate narcissist remained a virgin until the end. Pedophiles, lovers, creeps in drug stupors—nothing defiled her. The core Edie remained intact. "Edie tried to seduce everybody," as Nat says, "and fucked nobody." You can't desecrate an icon. By definition, it's an immaculate conception.

She was on the last slippery slope and sliding down the evolutionary rings at a giddy rate. She knew she couldn't stop herself and came to believe the only way she could put an end to it was to get busted. Two weeks later she is walking down the street, her purse opens out and spills hundreds of spansules, tablets, baggies filled with "Christmas trees," spindles spilling out powders, and tin-foil-wrapped home-cooked speed. A cop—had she beckoned him? turned herself in from some psychokinetic pay phone?— at that very instant cruises by. He busts her; it's what she wanted but she kicks him in the ass anyway. She gets five years probation. Edie is that character in the movies who provokes the audience to leap up from their seats and shout, "Watch out!" "Oh, no, don't go in there!"

She's in and out of loony bins, eventually checking into Cottage Hospital in Santa Barbara— where she was born on April 20, 1943 and where her father died—on the advice of her psychiatrist. And it's at Cottage Hospital that the ghouls from *Ciao! Manhattan* find her again in the summer of 1970. The producers get permission to take her out of a mental institution to finish their dopey film. They've got the early scenes, the Chuck Wein footage, a lot of loose scenes that they now try to integrate into an inane plot involving flashbacks to her former life—the black & white footage from 1967, plus photos, newspaper clippings, etc.

Edie is playing a character named Susan Superstar (i.e. Edie) who lives in a tent in an empty swimming pool decorated with blow-ups of Paul America, Andy Warhol, and Edie as her former self. Not to mention a Campbell's soup can wastepaper basket, Dylan and Shirley temple albums, the soundtrack from *Performance* (hint, hint), a chest of drawers, and a mattress on the floor strewn with photos.

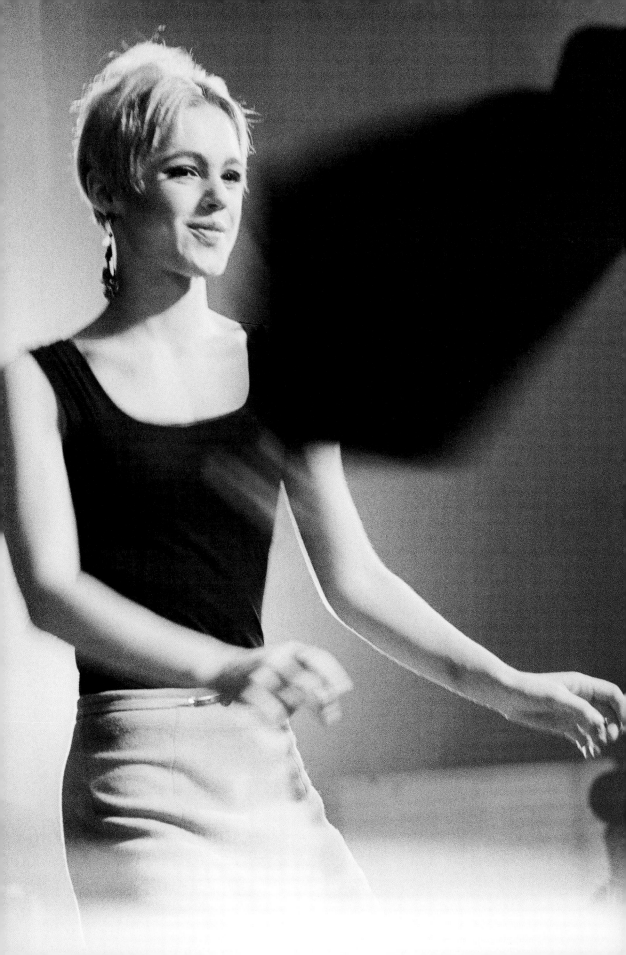

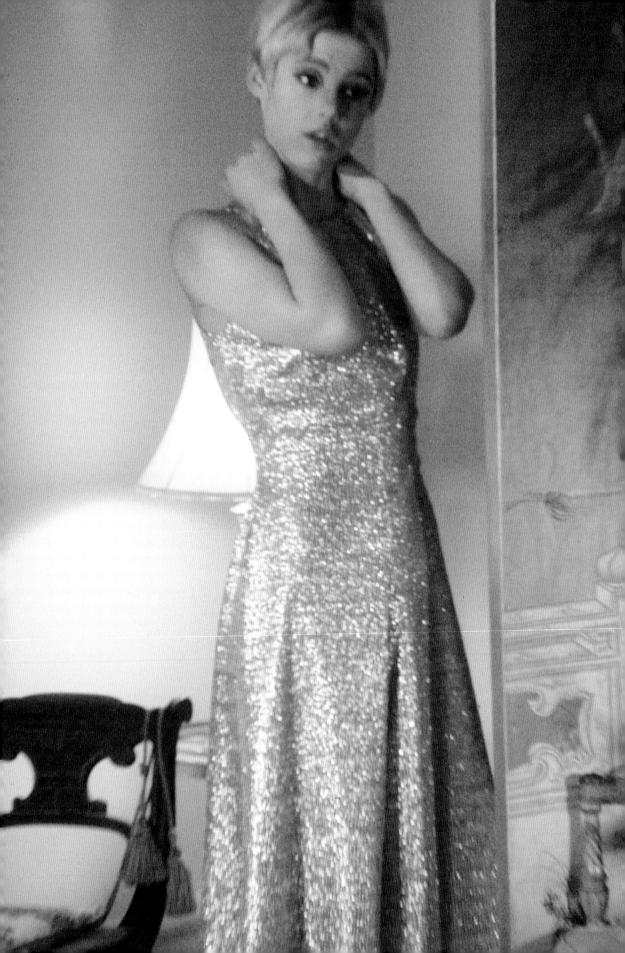

The Susan character no longer looks like the Edie of the mid-60s—she has long hair, she's had breast implants—and at first one is tempted to ask, "Who's playing Edie?" The odd thing is that this Edie looks younger than the Edie of the Warhol era. She is now a typical California hippie chick, as if the Susan character were anticipating rather than recalling her days of glory.

Doped on Seconal and vodka they have her reenact scenes with a Dr. Robert character shooting her up. She also gets shock treatments, walks around naked and rambles incoherently about her days of glory and deluded plans to take up her modeling career.

It's also during one of her stays at Cottage Hospital that Edie meets Michael Post, a sweet hippie who looks after her as they plan to start life over again. For a moment, at the beginning of 1971, things seem hopeful for Edie—despite undergoing shock treatments from January through June (and despite the horrors of filming *Ciao! Manhattan*). Edie and Michael are married July 24, 1971. The kitchen and living room in their apartment in Santa Barbara oddly resemble the sets of *Kitchen* and *Poor Little Rich Girl*, as if she were inhabiting scenes from her own life.

NOVEMBER 15 1971

Edie attends a fashion show at the Santa Barbara Museum where, coincidentally, her old friend from Cambridge, Tom Goodwin, is filming a segment of *An American Family* with another old friend, Lance Loud—it's the first reality show. After the show, a woman named Veronica Janeway viciously taunts Edie, calling her a heroin addict, saying her marriage won't last, that she's doomed. A full-blown harpy materialized out of Edie's paranoia pronounces her death sentence. Edie, who'd had a few drinks at the party, takes a handful of sleeping pills and ODs from acute barbiturate poisoning. She'd been a ghost

Edie Rising

MARIANNE FAITHFULL: Edie for me was a red light, blinking: "DON'T GO THERE!" Though I was nothing like Edie—I wasn't as clever, stylish, hip, cool, blah-di-blah—I got the feeling that had I gone to New York around that time and got into speed I'd have been chewed up and swallowed, unless of course I'd run away with Bob [Dylan] in which case I would've been totally protected. Edie, you see, didn't get an actual offer from Bob—I did. Her appeal, I'd say, was—and still is, amazingly—that she was a really cool chick. A lot of it is Andy, of course. Without Andy and all those guys—your Paul Morrisseys, your Ondines—I don't think Edie would've been all that interesting, a boring, spoiled, upper-class chick essentially. Andy was a genius and you can't always aspire to that. What you can aspire to is to be the consort of genius—and all that implies.

When Andy was told about her death he responded in his usual affectless way, as if he'd been informed about some happening on a distant planet.

But she continued, in her own mischievous way, to haunt Andy. Since she'd brought him out of his shell in the mid-'60s, Andy's mad social life had become a swirl of cocktail parties, openings, grand repasts—five different dinners a night! That social fog of entrances and exits, small talk and miniature dogs was his legacy from Edie, who loved nothing better than a party. But for Andy they must've seemed a kind of penance, the way Henry II had himself scourged at Thomas Becket's tomb. Andy had always been ill at ease and suffered through these louche feasts and fancy soirées filled with dread, wishing only to go home and watch *The Thin Man* on TV and gossip on the phone and go to sleep. As Andy sat numbly at some insufferable dinner party, he often must've seen the Tinkerbellish figure of Edie making faces at him from across the table.

Edie had been fading away in her own spectacular way for five years. She was the epitome of someone who had been famous for fifteen minutes—but for what, it wasn't easy to say.

And then something strange happened. Slowly, incrementally, the bizarre Leopard-Skin Pill-Box-Hat Cult began to emerge. Being essentially a teenage religion, it naturally focused on the very opposite such established values as common sense, mental health, stability, sobriety, and a split-level in Larchmont. The cult's sacramental wafer is any photograph of Edie in any condition. Communion with said photograph allows her acolytes to experience the rush of transubstantiation: a flashing pulse of energy as the filaments ignite in unadulterated narcissism, drug high, and pure childlike joy.

Patti Smith, Betsey Johnson, Kate Moss, aristocratic English girls, Polish girls, Afghan girls, professors of rhetoric, $2,000-an-hour hookers, arbitragers and jewelers have all inhabited Edie's unstable image—the idea of Edie the icon, in black tights and silver hair, about to take off in flight, her magic stallion behind her, scribbled on the wall of her tiny apartment. Edie is their Princess of Otherness. She's an anti-fashion fashion icon. Her oddities, her divergences from the norm are her glory.

Edie's disasters are seen as a form of stigmata, her flaws the very reason she is loved by her flock. She is their fucked-up martyr, an anti-saint of transgression and wretched excess. The world is bullshit; the bravest approach is to simply malfunction. Fucked-upness means you are healthy— all else is phoniness and rationalization.

Edie is the beautiful monster child created by indulgent parents. She represents the innocence and joy of the era, as well as the doomed soul willfully going to hell in a handbasket, as epitomized by Jane Anderson, a twenty-one year old Edie fan.

JANE ANDERSEN: Edie legitimized "acting out" by taking it beyond a rite of passage into something approaching a form of artistic expression. I can see a lot of people finding that attractive in the sense of, "Oh, I'm not really killing myself, making bad decisions, ruining my potential— I'm doing this for what in fact is my art." For a brief moment she defied the tired morality tale in which the bad girl comes to a bad end. On the contrary, you would be celebrated for flouting convention. For women especially, that is intoxicating and seductive. After I'd read *Edie* I probably spent the next two or three years thinking that was pretty much the epitome of existence. Like you could live your life on the edge and it was really a lot of fun—even the degradation part of Edie's life, when I thought self-destruction was really glamorous. Eventually I realized that this is the way sexual fantasies work: it's fine to construct them in your mind, but you're probably not going to follow through in reality.

But reality is not what most of Edie's fans are looking for. In the cult of Edie, her very artificiality becomes a virtue, and inauthenticity a value in and of itself—the only honest reaction to a hypocritical world. "The appeal is in part because she was synthetic," says eighteen-year-old fan Anoushka Beckwith. "She seemed an original, but at the same time she collaged everything from other people. Everything in life is recycled, and I guess I like her because of that."

Edie is the queen of image. Even her antisocial attitude is seen as a commendable piece of mockery, a kind of conformist anti-conformity. The Edie legend is yet another variation of the American dream at the core of every frothy, cotton-candy celebrity fantasy. Like Betsy Ross or Annie Oakley, Edie has entered the floating domain of our ongoing national vaudeville, an all-singing, all-dancing daydream in which emblematic figures hover like balloons at the Macy's Thanksgiving Day Parade.

Edie's disciples make a fetish even out of her vacuity. She's hallowed for a kind of absence, a hollowed-outness, an extraterrestrial void that generates fierce attractions. Even her neurasthenia and her fragility are seen as emblems of her peculiar grace. "Her eyes, those big doe eyes," says eighteen-year-old fan Sana Amini, "she's a wonderful, beautiful blank."

Edie is now essentially a photograph, someone whose renown is based almost entirely on superficialities: her image, her style, her look. But what is compelling about her is her Otherness. There is an otherworldliness to Edie, she's like a changeling, or one of those long-legged gossamer creatures you see alighting on a leaf in children's books.

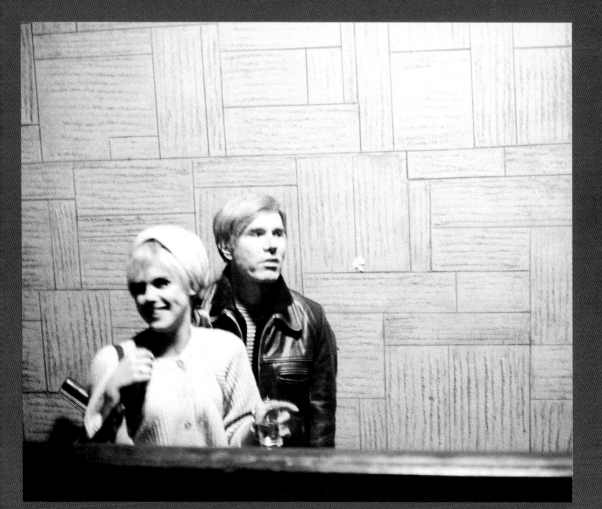

DANNY FIELDS: Edie was sort of extra-planetary. Like Andy. She was like one of those magic fairy people that come into your life, and then the wind comes along and sweeps them away—it could be the wind of death, it could be the wind of fame, it could be the wind of other people. It comes along and takes them back to wherever they came from.

PARADOXICALLY, EDIE'S DAZZLING OUTER SHELL WAS THE RESULT OF HER PAINFUL INNER TURMOIL. IN THAT DAMAGED INTERIOR, SHE CONSTRUCTED A MINIATURE THEATER WHERE SHE SPUN WHIMSICAL TALES AND PROJECTED FANTASTIC SCENES—IT WAS THE SOURCE OF THAT INNER ILLUMINATION THAT SO MANY PEOPLE REMARKED ON. AN ELFIN CREATURE WHO DEFIED THE LAWS OF LOGIC, GRAVITY, AND COMMON SENSE IN PURSUIT OF SOMETHING SO TRIVIAL AND EPHEMERAL IT SEEMS ALMOST MYSTICAL.

MOVIES ARE A KIND OF AFTERLIFE, AND IT'S EASY TO THINK OF EDIE IN *OUTER AND INNER SPACE*, BEAMING HER IMAGE TO US FROM SOMEWHERE OUT THERE, AS SHE GOES ON TALKING TO HERSELF ENDLESSLY, SMOKING CIGARETTES THROUGH ALL ETERNITY.

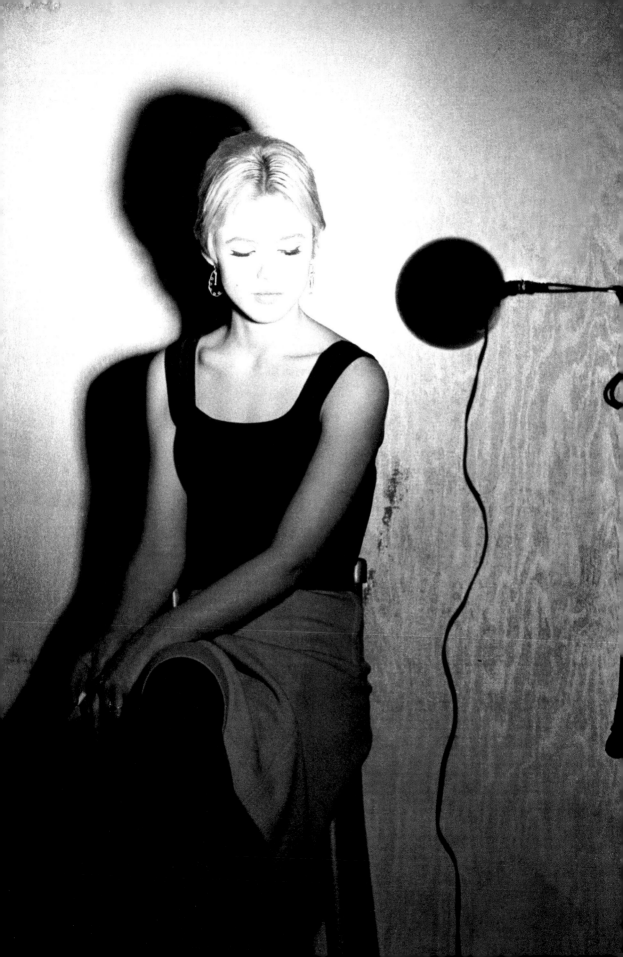